LOST
MEMPHIS

LOST
MEMPHIS

LAURA CUNNINGHAM

THE
History
PRESS

Published by The History Press
Charleston, SC 29403
www.historypress.net

Unless otherwise noted, all photographs, including the front cover, are courtesy of the
Memphis and Shelby County Room, Memphis Public Library & Information Center.

First published 2010

Manufactured in the United States

ISBN 978.1.59629.830.9

Library of Congress Cataloging-in-Publication Data

Cunningham, Laura.
Lost Memphis / Laura Cunningham.
p. cm.
Includes bibliographical references and index.
ISBN 978-1-59629-830-9
1. Memphis (Tenn.)--History--Pictorial works. 2. Memphis (Tenn.)--Social life and
customs--Pictorial works. 3. Memphis (Tenn.)--History. I. Title.
F444.M543C86 2010
976.8'19--dc22
2010029503

For Dick, Carolyn, Joyce and Eli

CONTENTS

ACKNOWLEDGEMENTS

No serious study of Memphis history can be completed without the resources of the Memphis and Shelby County Room. Located at the Benjamin L. Hooks Central Library, this collection contains the most comprehensive resources for the research and preservation of Memphis and local history. I would like to acknowledge everyone who has worked to preserve this collection over the past seventy years, whether as an employee or volunteer. Your dedication to the preservation of all things Memphis is commendable and deserves to be recognized.

I would also like to thank my colleagues in the History Department at the Benjamin L. Hooks Central Library: Betty Blaylock, Joan Cannon, Gina Cordell, G. Wayne Dowdy, Sarah Frierson, Jasmine Holland, Verjeana Hunt, Thomas Jones, Belmar Toney and Marilyn Umfress. Each of you offered encouragement, suggestions, assistance and general support. I would also like to extend a sincere note of gratitude to Hugh Higginbotham, a wonderful man whose knowledge and love for Memphis inspires me.

Finally, I would like to thank my family: Jim and Lela Cunningham, Anna and Keith Edmondson and Eli Morrison. Thank you for everything.

INTRODUCTION

To a native, no other city is as rich in history and culture as Memphis, Tennessee. To completely capture its significance would be an impossible task. *Lost Memphis* offers only a glimpse of Memphis, from its earliest beginnings to the present. It focuses on aspects of the city's history that no longer exist, whether due to urban renewal, advancements in technology, or changes in society.

Photographs provide an alternative format for remembering, preserving and sharing our history, often providing a deeper understanding in a way words cannot. The photographs selected for this book include not only prominent landmarks and historic events—topics familiar to most Memphians—but also smaller subjects, nearly forgotten by time. The topics define Memphis, and these images reflect this. To an extent, *Lost Memphis* follows the city's development as it grew out of the wilderness overlooking the Mississippi River into the metropolitan city it is today. Certain themes, such as agriculture and transportation, were crucial to Memphis's history and are thus represented.

The most difficult task in compiling this book was not selecting which photographs to include but deciding which to omit. Although most photographs seen here are from the late nineteenth to mid-twentieth century, images from recent history are also included. These range from the 1968 Sanitation Strike to the Mall of Memphis. Hopefully, *Lost Memphis* will allow readers to remember the city's past, good and bad, while also preserving it for the future.

THE EARLY YEARS

The area now known as Memphis, Tennessee, was inhabited at least 10,000 years before the first Europeans arrived in the area. These Europeans, Spaniards under the direction of Hernando De Soto, arrived in May 1541. Although the exact location where De Soto first sighted the Mississippi River is unknown and highly debated, Memphians proudly credited their city with this recognition. After De Soto passed through the area, 130 years lapsed before more Europeans arrived. Over time, France, Spain and England would each stake its claim in the region.

In 1783, the State of North Carolina sold land speculator John Rice a five-thousand-acre tract of land in what would become downtown Memphis. In 1794, Rice was killed by Native Americans near his home in Clarksville, Tennessee, at which point his brother sold the land to another land speculator, John Overton. Overton sold a portion of the acreage to his close friend Andrew Jackson, who in turn sold a portion to James Winchester. The land remained undeveloped and under the control of the Chickasaws until 1818, when it was ceded to the United States.

In May 1819, Overton, Jackson and Winchester joined together and laid out a plan for developing the area. James Winchester suggested naming the new community after the ancient Egyptian city of Memphis, similarly situated on the Nile River. In designing the city, the three men insisted on public spaces, which led to the creation of Court, Auction, Exchange and Market Squares. Thirty-six acres of land were later set aside and dedicated for a public promenade, meant to extend from Jackson Avenue south to

Union Avenue. Of this public promenade, only Confederate and Jefferson Davis Parks remain. One hundred years later, the Memphis and Shelby County Centennial Celebration Association selected the week of May 19, 1919, to properly celebrate the anniversary of the city's founding with daily parades and other special events.

Memphis owed its success to its commanding position on the Fourth Chickasaw Bluff, named for being the fourth bluff downstream from Fort Pillow Bluff. The location provided some protection from flooding, and the commanding position proved suitable for river traffic and trade. Initially, Memphis grew slowly due to disease, rival neighboring communities and a reputation as a wild river town. Although it was still considered a frontier town, Memphis began to experience rapid growth during the 1840s. By 1860, Memphis was a firmly established city and transportation center, with over twenty thousand residents and a large commercial district.

Transportation and agriculture, specifically cotton, provided the economic base for the city. Cotton, grown on the rich, fertile farmland that surrounded Memphis, could easily be transported in and out of the city by river or rail. Many local businesses focused on the cotton market maintained relationships not only with southern farmers, but also with the textile industry in the Northeast. As a result of these relationships, Memphians were extremely hesitant about secession preceding the Civil War.

On June 6, 1862, Federal forces took control of Memphis following a river battle that lasted less than ninety minutes. Fortifying the city became one of the first priorities. A two-mile section of riverfront became Fort Pickering, named after a defunct town and a separate frontier outpost, both of which were once located in the vicinity. The fort, large enough to accommodate ten thousand men, fronted the Mississippi River for two miles, from Beale Street south to present-day Chickasaw Heritage Park.

On August 21, 1864, Confederate general Nathan Bedford Forrest led fifteen hundred men on an early morning raid into Memphis. The men planned to capture the three Union generals living in the city, to release the Confederate prisoners held at the Irving Block prison and to draw the Union forces out of northern Mississippi and back into Memphis. One Union officer, General Cadwallader Colden Washburn, escaped capture by fleeing to nearby Fort Pickering wearing only his nightshirt. The General Washburn Escape Alley in downtown Memphis now marks his route taken that morning. In a dramatic attempt to capture General Stephen A. Hurlbut, Captain William H. Forrest, brother to Nathan Bedford, rode his horse through the lobby of the prestigious Gayoso House demanding at the

front desk to see the general. General Forrest's men retreated by noon, only succeeding in recalling the Union troops out of Mississippi.

Undoubtedly, the years following the Civil War were the darkest in the city's history. At the war's end, large numbers of African Americans arrived in Memphis seeking aid from the Bureau of Refugees, Freedmen and Abandoned Lands. The Freedmen's Bureau, as it was familiarly known, established refugee camps in the Memphis area, including one for over fifteen hundred freed slaves on President's Island. At the time, the financially burdened city was ill equipped to handle such a large growth in population. As the city began to rebuild, tension ran high between members of the African-American and Irish communities in Memphis. In May 1866, the growing tension accumulated into three days of rioting, leaving forty-eight African Americans and two white Memphians dead.

Over the next decade, Memphis struggled as the population dramatically decreased due to several outbreaks of disease, yellow fever being the most severe. In 1878, Memphians faced the worst epidemic in the city's history. In the late summer and early fall, an estimated twenty-five to twenty-seven thousand residents fled upon hearing of the city's first confirmed yellow fever death. Of the remaining twenty thousand citizens, over five thousand died as a result of the disease. The outbreak left the city bankrupt, and the State of Tennessee revoked its charter. Memphis operated as a taxing district until 1893.

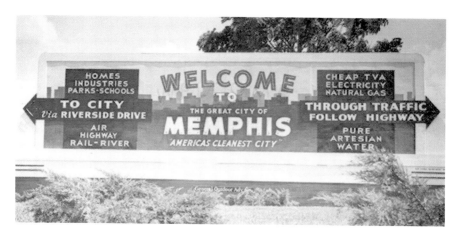

Welcome to Memphis, five-time winner of the title "Nation's Cleanest City."

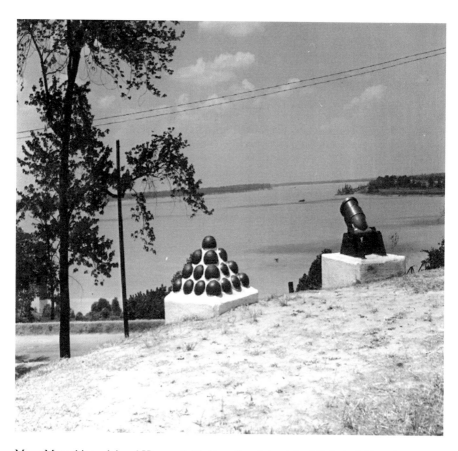

Many Memphians claimed Hernando De Soto first sighted the Mississippi River from Chisca Mound, located in present-day Chickasaw Heritage Park.

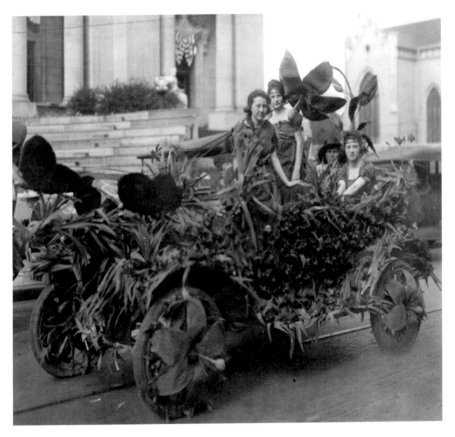

In May 1919, Memphians celebrated the city's centennial with a week of parades, parties and other festivities.

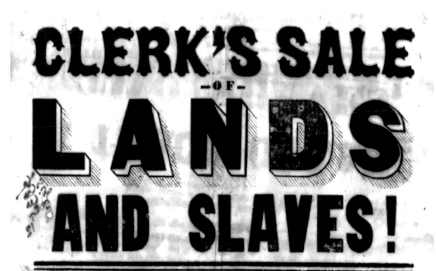

CLERK'S SALE
—OF—
LANDS
AND SLAVES!

By virtue of a decree of the County Court of Shelby County, made at the December Term, 1855, upon the petition of the heirs of JOHN B. PERSON, deceased, for the sale of Real Estate for partition, I will offer at public sale.

AT THE COURT HOUSE IN RALEIGH,
ON THE 1st DAY OF JANUARY, 1856,

This 1855 broadside advertised a clerk's sale for land and slaves in Raleigh, Tennessee. Raleigh, once a separate city from Memphis, served as the county seat from 1827 to 1867.

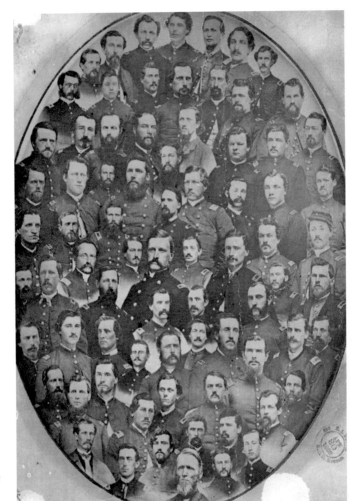

Right: These Union officers are believed to have been the garrison staff of Fort Pickering.

Below: *Harper's Weekly* depicted General Nathan Bedford Forrest's raid into Memphis. According to local legend, Forrest's brother, Captain William H. Forrest, rode his horse through the lobby of the Gayoso House in an unsuccessful attempt to capture General Stephen A. Hurlbut.

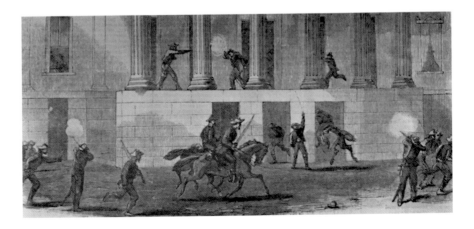

A Civil War camp, located near Memphis. *Official U.S. Navy photograph.*

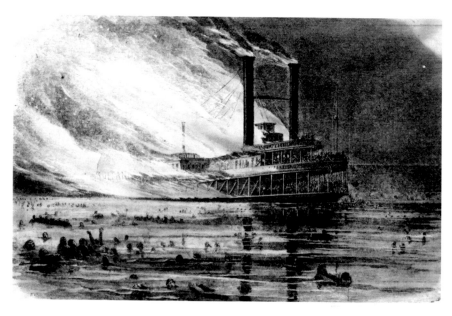

In the early morning of April 28, 1865, the steamboat *Sultana* exploded just north of Memphis. An estimated eighteen hundred of the ship's twenty-five hundred passengers, the majority of whom were returning Union soldiers released from Confederate prisons, lost their lives.

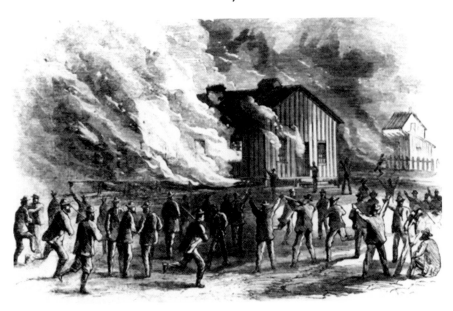

Following the Civil War, escalating racial tension resulted in the Memphis Race Riot of 1866. Over a three-day period, dozens of African-American churches, schools and homes burned, and approximately forty-eight African Americans were killed.

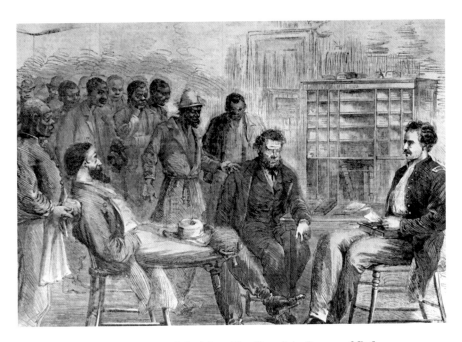

Harper's Weekly featured sketches of the Memphis office of the Bureau of Refugees, Freedmen and Abandoned Lands. The Freedmen's Bureau provided assistance for refugees following the Civil War.

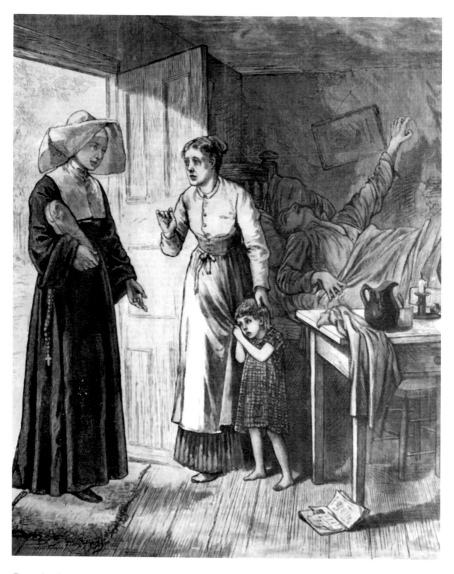

Organizations such as the Sisters of Charity cared for ailing Memphians during the 1878 yellow fever epidemic, the worst in the city's history.

AGRICULTURE

COTTON WAS KING AND CARNIVAL QUEENS

For most of the city's history, agriculture—specifically cotton—dominated the Memphis economy. In 1826, the Memphis market received its first cotton shipment, three hundred cotton bales from nearby Fayette County. In July 1926, one hundred years later, Memphis broke all previous records, having received nearly two million cotton bales into the market. Cotton dominated the economy, which earned the crop the nickname "King Cotton." In 1941, Memphis proudly graduated from the "world's largest inland cotton market" to the "world's largest cotton market." Although the city no longer stakes claim to either title, the crop played an extremely important role in Memphis's development.

All grades of cotton grew throughout the deltas of Arkansas and Mississippi, one of the most productive agricultural regions in the world. Originally, cotton harvesting was done by hand, a process that was both labor intensive and time consuming. In 1850, Memphians Samuel S. Rembert and Jedediah Presscott received the first patent for a mechanical cotton harvester. Over the next century, inventors experimented with hundreds of various designs for harvesting devices before a commercially successful machine was produced. Despite these advances, many farmers continued to harvest the crop by hand, unable to afford the cost of machinery. After the Civil War, the economic cost of land and labor led to the development of the sharecropping system. Former slaves, who could not afford their own land, provided landowners with labor in exchange for a small portion of the crop's profits. Labor shortages during and following World War II greatly diminished the system, which was all but finished by the 1960s.

Once cotton had been harvested, it was taken to be ginned and baled before being sent to Memphis, where it would be classified, sorted and stored. In 1873, Memphis businessmen founded the Memphis Cotton Exchange, an organization that helped regulate the buying and selling of cotton. Although few remain, businesses of cotton factors and other cotton-related merchants lined Front Street. Memphis became a natural distribution center due to its location and transportation capacities, which included the Mississippi River and railroads. Steamboats overflowing with cotton bales unloaded their cargo on the wharf. These boats were later replaced by barges with the capacity to hold thousands of cotton bales in a single trip. Large quantities of cotton also shipped in and out of Memphis via the railroads. Later, much of this traffic was diverted to barges and trucks.

The cotton economy also included its allied industries, such as cottonseed and oil products, machinery and supplies such as pesticides and fertilizers. The products made with the seed and oil from cotton ranged from salad dressing and laundry soap to Kodak film and tires. Tires were once constructed of rubber-insulated cotton cords. At one time, the tire industry was the second-largest consumer of cotton. Firestone Tire and Rubber Company, once one of Memphis's largest employers, maintained a forty-acre facility in the city for nearly fifty years.

Although cotton was always in demand, interest in the crop dwindled during the early twentieth century. During the Great Depression, Memphians established the Cotton Carnival as a way to promote the use of cotton goods and increase sales. The fanfare and celebration during the weeklong event were similar to early Mardi Gras festivals held in the city. The Memphis Cotton Carnival Association and members of its Grand Krewes held parades, parties and other festivities, in addition to electing carnival royalty. Memphis dentist Dr. R.Q. Venson established the Cotton Makers Jubilee to highlight the contributions of African Americans to the cotton industry. In 1935, the National Cotton Show held at the city's fairgrounds also helped promote Memphis cotton to the world.

In addition to cotton, several agricultural crops prospered in the Memphis market. In the late 1800s, hardwood lumber emerged as the second-largest industry in the Mid-South. Sawmills emerged throughout the Mid-South, bringing more woodworking manufacturers to the area. Several dairy farms were also located on suburban land outside the city. The Shelby County Penal Farm took advantage of the area's rich, fertile land by becoming one of the premier penal institutions in the country. After the farm closed in 1964, forty-five hundred acres of farmland became Shelby Farms Park, one of the largest urban parks in the United States.

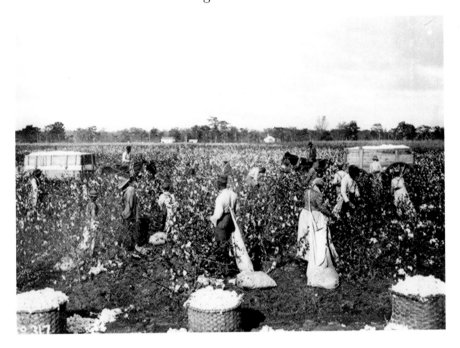

Workers of all ages picked cotton in Arkansas fields.

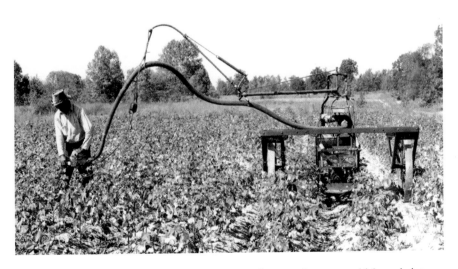

Here, a farm worker demonstrates an early pneumatic cotton harvester, which used air to remove the fibers from cotton bolls.

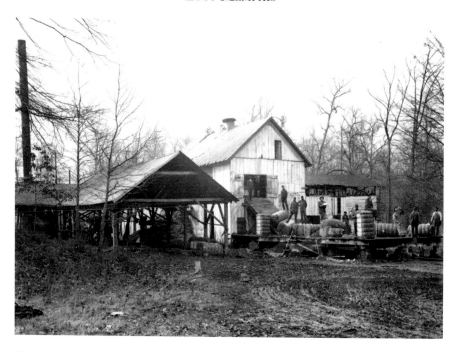

Cotton gins rapidly appeared throughout the South. Their vast numbers and locations ensured a farmer would not have to travel more than a day's drive by wagon in order to get his cotton baled.

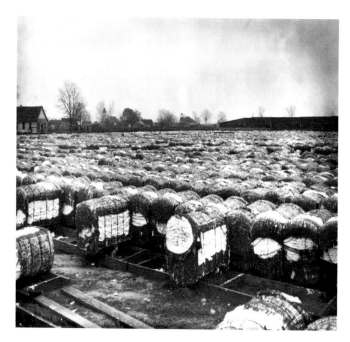

Before being shipped, cotton bales were stored in large warehouses. After the warehouse reached its capacity, bales were stored outside.

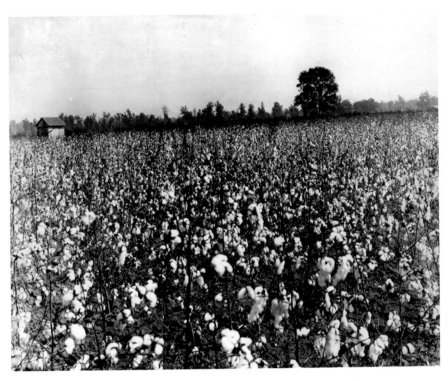

Sharecroppers often lived in small shacks adjacent to the fields they farmed.

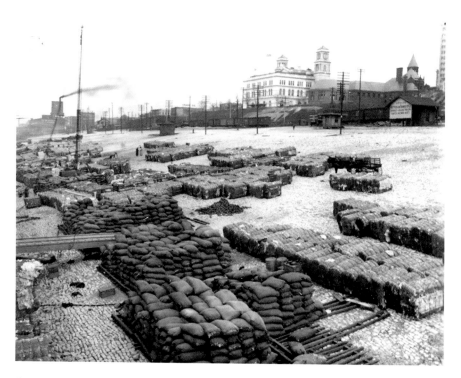

Cotton bales were commonly seen along Memphis's cobblestone landing. 1900.

Agriculture

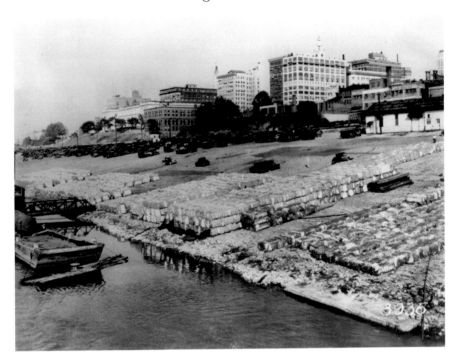

Cotton bales line the wharf, ready to be loaded onto waiting boats.

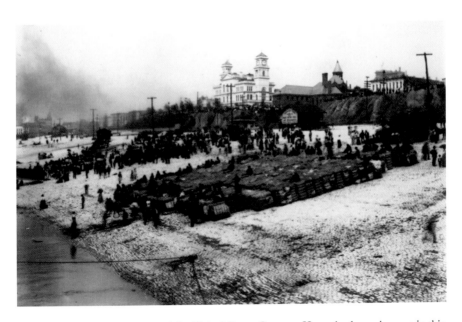

The tower at Cossitt Library and the United States Customs House both can be seen in this photograph of the river landing.

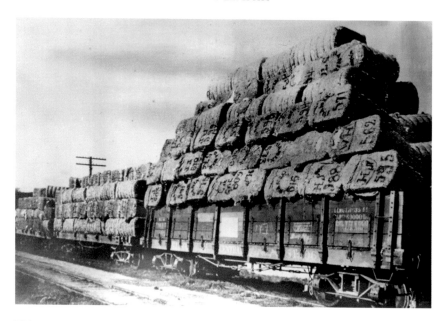

This train carried one of the largest loads of cotton to come into Memphis. 1906.

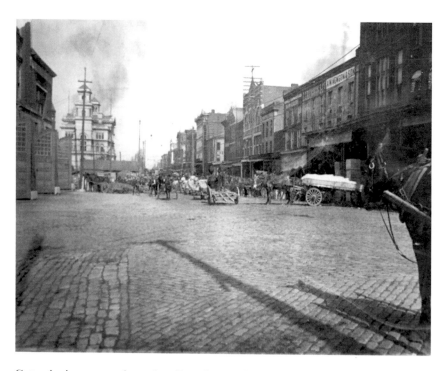

Cotton businesses were located on Front Street, allowing easy access to river and railroad traffic. Circa 1890s.

Front Street, facing north from the intersection of Madison Avenue. Circa 1960s.

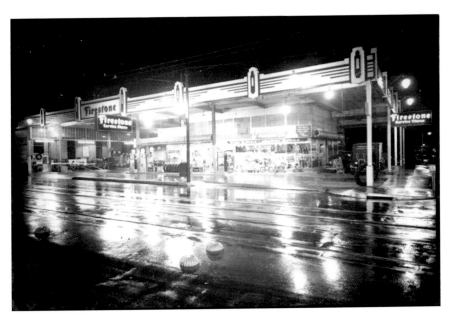

In addition to a large factory, Firestone maintained several neighborhood auto supply and service stores. 1940.

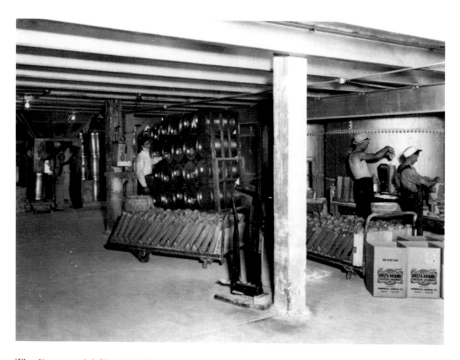

The Commercial Chemical Company produced calcium arsenate, a chemical effective in controlling the boll weevil.

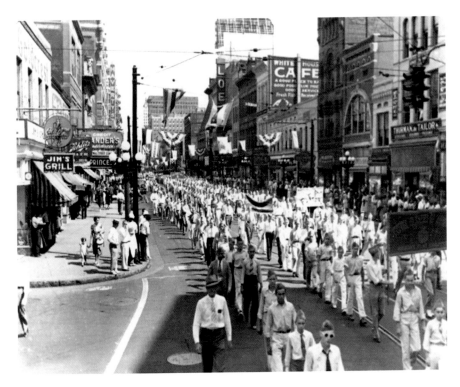

The Cotton Carnival began in 1931, with traditions dating back to early Mardi Gras festivals held in the 1870s and 1880s. Circa 1940.

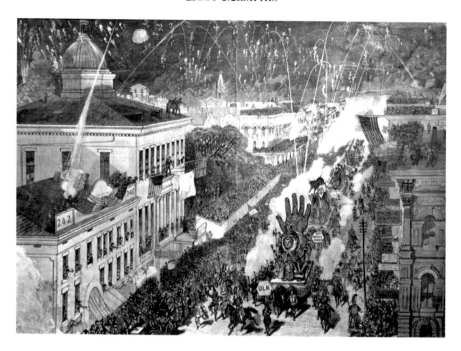

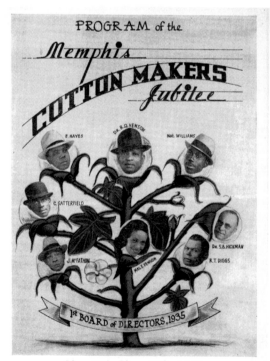

Above: The Ulks of Memphis marched down Main Street during the 1878 Mardi Gras celebration.

Left: The Cotton Makers Jubilee, held parallel to the Cotton Carnival, focused on the contributions of African Americans to the cotton industry.

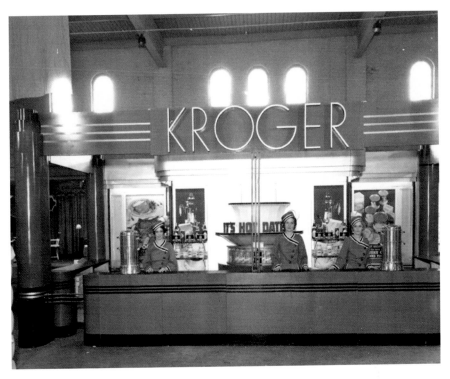

Memphis hosted the 1935 National Cotton Show at the Mid-South Fairgrounds. Featured here is an exhibit from Kroger.

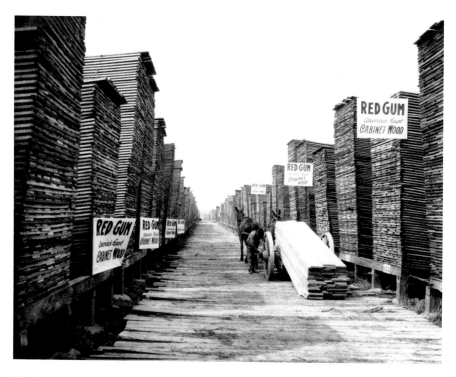

Hardwood lumber was the second-largest agricultural industry in Memphis, earning the city the title "Hardwood Capital of the World."

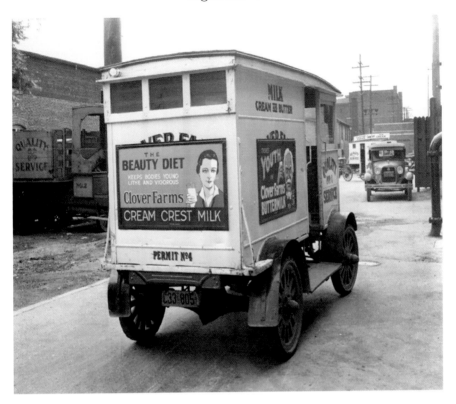

Memphis's last horse-drawn milk wagon, from the Clover Farm Dairy Company, disappeared from the city's streets in 1947.

The Shelby County Penal Farm opened in October 1929 on Mullins Station Road, soon becoming one of the top penal institutions in the United States.

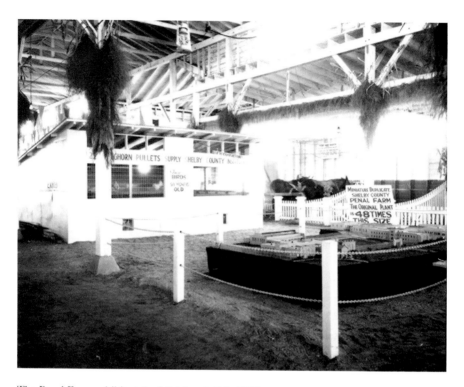

The Penal Farm exhibit at the Mid-South Fair. 1933.

TRANSPORTATION AND THE MISSISSIPPI RIVER

A key component in Memphis's economic growth and development was its emergence as a transportation and distribution center. As the city grew from its humble river-town origins, railroads and the Mississippi River became essential to its success. Early transportation and trade on the river originated with flatboats. Technological advances and improved navigation led the way for steamboats to take over. Steamboats allowed visitors to travel the river in luxury, while their speed increased trade and eased communication. Steamboat lines transported goods to small communities along the Mississippi, eventually building connections from Minnesota to New Orleans, in addition to communities along the Ohio and Arkansas Rivers. By the end of the nineteenth century, railroads had triumphed over steamboats as the chosen method for transporting goods. Steamboats continued to decline, eventually being replaced by diesel-fueled vessels.

In 1892, Memphis advanced as a transportation center with the opening of the Great Bridge. The bridge's new railroad connections made trade with the western states readily accessible. Later renamed Frisco, it remained the only bridge in Memphis until the Harahan Bridge opened in 1916. In addition to increasing the city's railroad connections, the Harahan also allowed for automobile traffic. In 1928, a fire destroyed the bridge's wooden roadways. Although the roads were rebuilt, automobile traffic ended on the Harahan in 1949 with the opening of the Memphis-Arkansas Bridge. Exclusively for automobile traffic, the Memphis-Arkansas served as the city's only vehicular bridge until the Hernando De Soto Bridge opened in 1973.

By nature, the Mississippi River is fickle. Despite the city's elevated location on the bluff, Memphis was affected by four of the largest floods of the twentieth century. On March 24, 1912, the Mississippi River reached the flood level at Memphis. It would be sixty days before the high water levels receded below the flood line. As a result, the water level of the Wolf River in northern Memphis rose and flooded a twenty-five-block area of the city known as the Pinch District. The city quickly established a relief center at the Tri-State Fairgrounds, which was named Camp Crump in honor of Memphis's mayor.

In 1913, this same area flooded again following a break in the Mississippi River levee. Although the Great Mississippi River Flood of 1927 is remembered in history as the most destructive of the river's floods, the 1937 flood created a much larger disturbance in Memphis and the surrounding region. In 1937, over twenty thousand displaced southerners sought shelter and aid in Memphis. The fairgrounds, along with hotels, schools and homes, once again aided refugees. In addition to flooding, the Mississippi River has also caused destruction on rare instances by freezing over during extremely cold winters.

In the mid- to late twentieth century, Memphis expanded its distribution capabilities as it became a leading aviation center. Memphis had an early start in aviation history. In 1910, the city hosted the National Aviation Meet at the fairgrounds. The event featured several contests and races between flying machines, automobiles and motorcycles. In 1927, Memphis mayor Watkins Overton created a Municipal Airport Planning Commission to develop plans for a regional airport. The commission selected two hundred acres of farmland located seven miles from downtown as its location. The airport opened in 1929 with modest facilities. In 1938, the airport added a terminal to handle increased passenger and aircraft traffic. Today, the Memphis International Airport has the distinction of being the world's busiest airport for cargo traffic, a title it's held for over fifteen years.

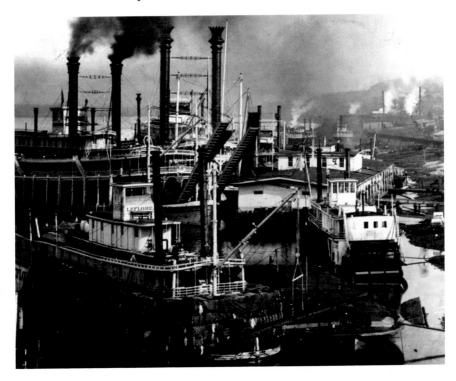

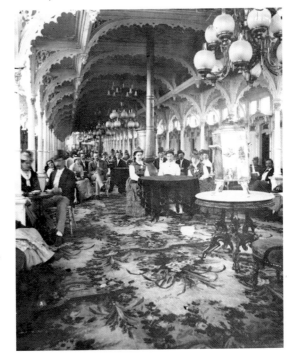

Above: The wharf was often the busiest spot in Memphis. The *Leflore* is seen in the foreground.

Right: The *Great Republic*, later renamed the *Grand Republic*, traveled the Mississippi River between St. Louis and New Orleans. A fire destroyed the ship in 1877.

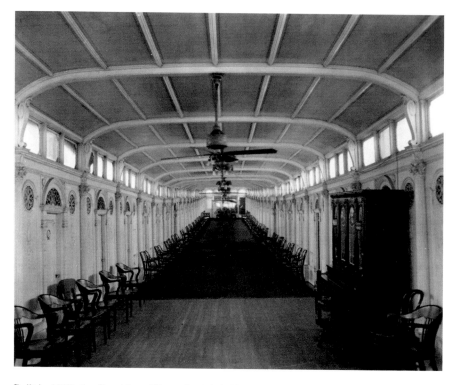

Built in 1898, the *Kate Adams III* was the third ship to carry its name. The steamboat was also used for scenes in the movie *Uncle Tom's Cabin*.

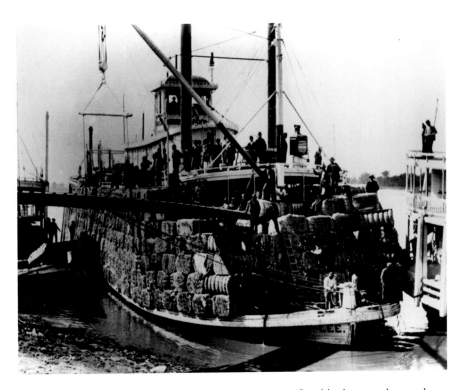

The *Lady Lee*, seen here loaded with cotton, sank two years after this photograph was taken when high winds blew it against a snag in the river. 1880.

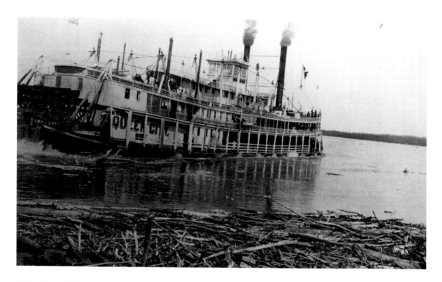

The *Queen City* packet boat, seen here at Memphis during high water, traveled between Cincinnati and New Orleans. 1900.

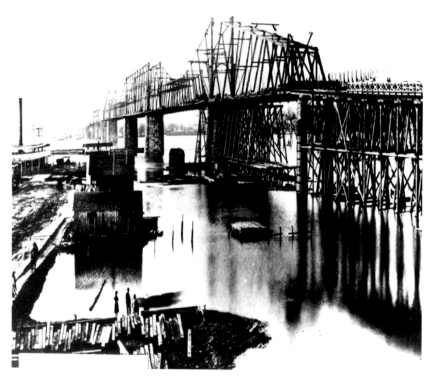

The Great Bridge at Memphis, later renamed Frisco, became the first bridge to span the lower Mississippi River south of St. Louis.

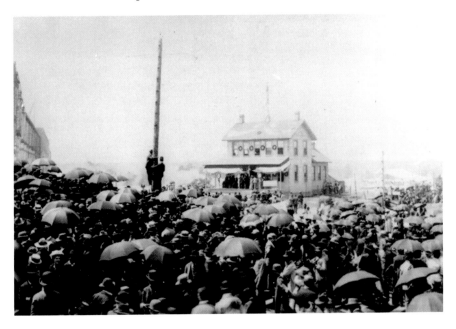

When the Great Bridge opened on May 12, 1892, it became the longest bridge in North America and the third-longest bridge in the world.

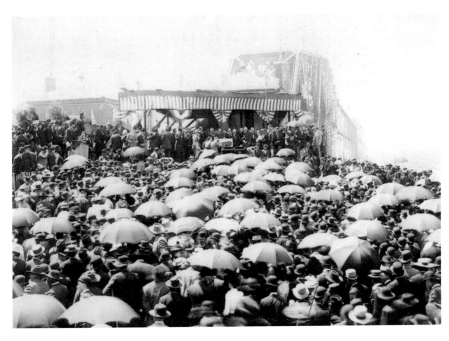

An estimated fifty thousand people arrived in Memphis to witness the opening of the Great Bridge.

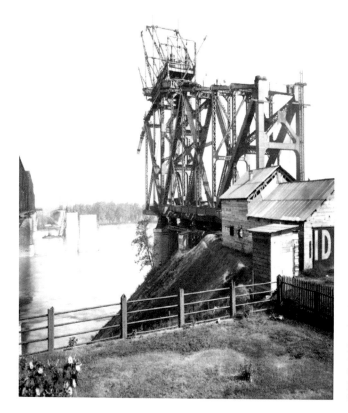

Harahan Bridge, completed in 1916, allowed for both railroad and automobile traffic. Brave drivers accessed a one-lane, wooden-plank roadway in each direction.

In 1959, the Civic Center Advisory Committee predicted a suspension bridge in Memphis as they designed plans for a revitalized downtown Civic Center.

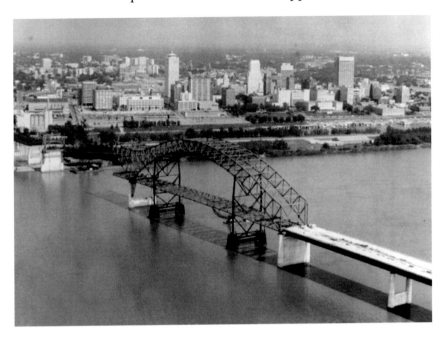

The Hernando De Soto Bridge, seen here during the building process, opened in 1973.

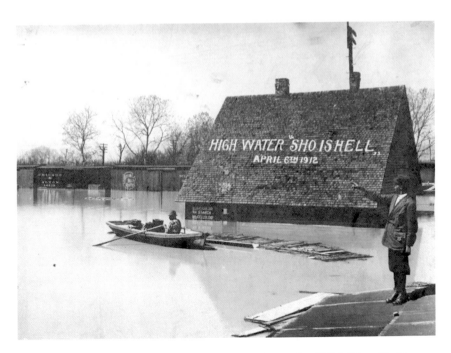

J.C. Coovert captured this flooded scene, providing the caption "High Water Sho' is Hell." April 1912.

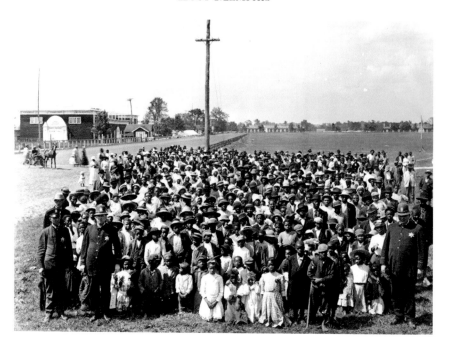

During the 1912 flood, the Tri-State Fairgrounds became Camp Crump, a center for displaced southerners fleeing floodwaters.

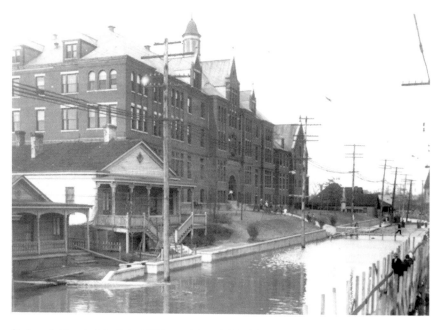

St. Joseph Hospital, built in 1895, was Memphis's oldest continuously run hospital until it closed in 1998. April 1912.

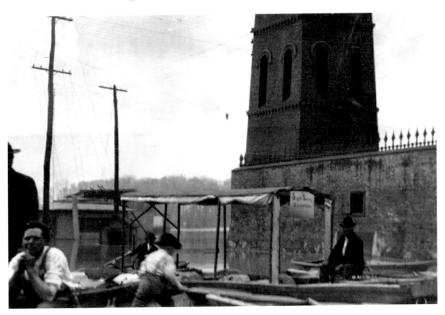

The Shelby County Jail, built in 1868, can be seen in this image of the 1913 flood. Although the city's dog pound later replaced the jail, the iron fence remains.

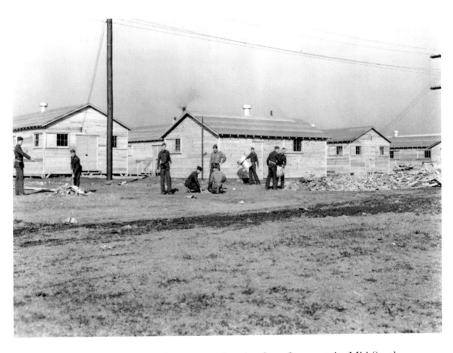

The National Guard constructed temporary housing for refugees at the Mid-South Fairgrounds during the 1937 flood.

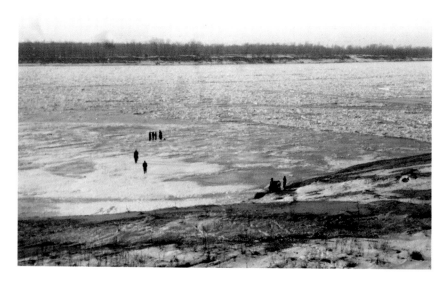

In 1940, the Mississippi River froze at Memphis for the third time since the Civil War.

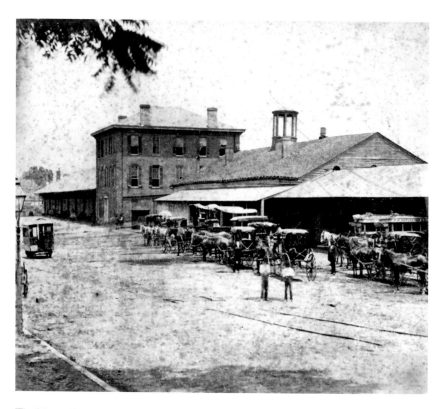

The Memphis and Charleston Railroad, completed in 1857, provided the first connection across the southern United States, linking the Mississippi River to the Atlantic Ocean.

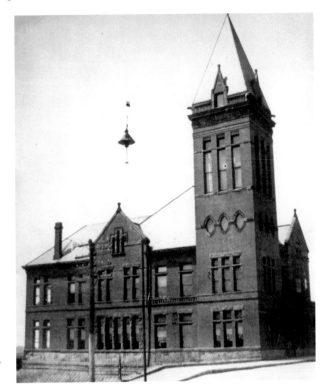

Right: The Poplar Street Railroad Station opened in 1890. Railroad engineer John Luther "Casey" Jones departed from the station on his fatal trip on April 30, 1900.

Below: The Poplar Street Railroad Station can be seen in the background of this bird's-eye view of Front Street. 1895.

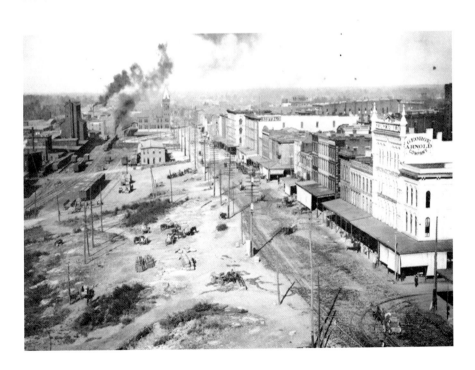

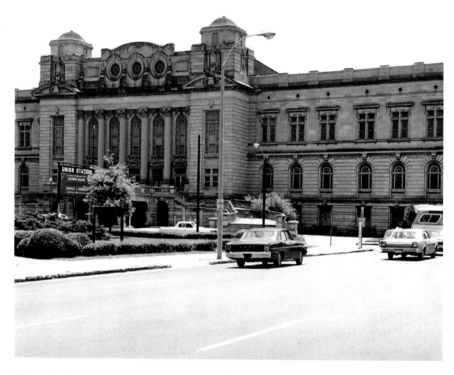

Union Station opened in 1912. The elaborate Beaux-Arts facility was later replaced by the United States Postal Service Automated Handling Facility. 1967.

Transportation and the Mississippi River

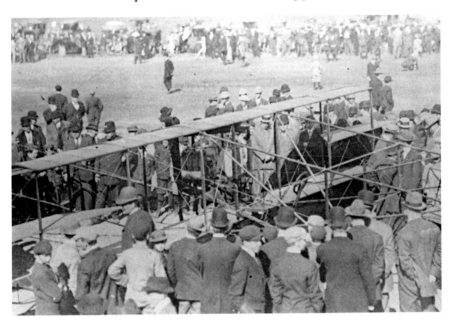

Memphians crowded around the "flying machine" before the opening of the National Aviation Meet. April 1910.

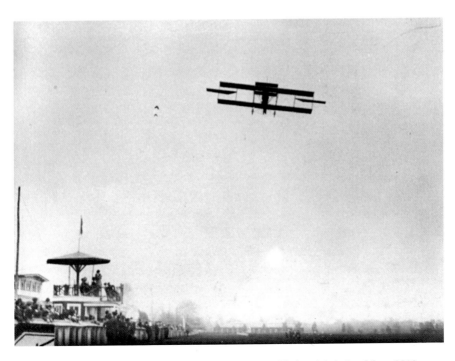

Aviation pioneer Glenn Curtiss flew *Miss Memphis* at the National Aviation Meet. 1910.

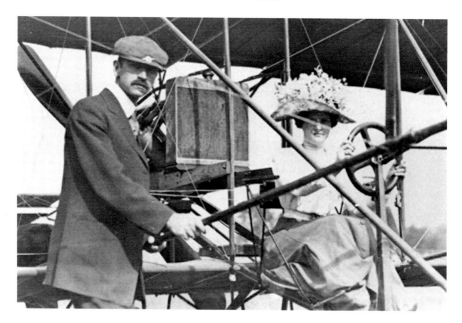

During the National Aviation Meet in 1910, Glenn Curtiss and his wife, Lena, took to the air for a short flight above the fairgrounds. This marked the only occasion Lena Curtiss flew in an early aircraft.

The Memphis Municipal Airport opened in 1929 with only three airplane hangars and a sod field runway. The airport added its first terminal in 1938.

SERVING THE PUBLIC

Despite its early decades of war, disease and bankruptcy, Memphis began to truly prosper at the end of the nineteenth century. At this time, the city focused on meeting the needs of its residents, with an emphasis placed on health, safety, civic pride and education. Streets were paved, a board of health was established and fresh water was supplied to all Memphians. The city government continued its safety trend, which included ensuring that Memphians had safe transportation, well into the next century.

As the city grew, it became necessary to build larger public buildings to accommodate the growing population. In the early twentieth century, Memphians received impressive public facilities that featured Classical-style architecture. Under the direction of Mayor E.H. Crump, the city received new headquarters for both the fire and police departments that blended in with the similarly styled Shelby County Courthouse and United States Customs House. Not only did these buildings instill pride in the workers, but they also left a grand impression on the city's visitors.

Memphians also placed a high value on education. The demolition of the original Cossitt Library deprived the city of one of its most architecturally and historically significant landmarks. Built in 1893 on South Front Street, the Cossitt Library was the first public library in Memphis. It was financed by the daughters of Frederick H. Cossitt, a dry goods businessman who established himself in Memphis before later moving to New York. In 1924, the library expanded with a rear addition that complemented the red sandstone structure. In 1958, the original building was demolished and replaced with a

more contemporary facility. No attempt was made to architecturally connect the rear addition with the new structure. In 1955, the Main Library opened on Peabody Avenue. This library served the community until 2001, when an even larger facility opened on Poplar Avenue.

As the city grew, branch libraries were built throughout the city. In 1938, a library opened on Vance Avenue to serve the African-American community. The library burned down in July 1978, on the first evening of the Memphis fire- and policemen strike. In a July 7, 1978 article for the *Commercial Appeal*, library director C. Lamar Wallis poignantly commented, "It was the first Negro branch library, the first separate branch building of the city system, the first city library to use bookmobiles, and the first library to be burned to the ground."

Memphis also maintained a well-established school system. The city received a charter for its first school system in 1826. At this time, all schools were privately organized and remained so until 1848. The city's first free school opened that year, soon followed by the development of a free school system throughout the city. In 1868, the city began supporting public schools for African Americans. Memphis High School, the city's first public high school, opened in 1897. Memphis offered a variety of schools to meet the community's needs; these included private institutions, seminary schools, colleges and universities. LeMoyne-Owen, a historically black college, traced its history to the LeMoyne Normal and Commercial School, which operated on Orleans Street for over forty years before moving to a location on Walker Avenue in 1914. The school later became a junior college before becoming a baccalaureate institution in 1934. At that time, the name changed to LeMoyne College. A second school, Owen Junior College, which opened in 1953, merged with LeMoyne, becoming LeMoyne-Owen College in 1968.

During the Progressive Era, several Memphians worked to improve the quality of life for others. Activists Susan Conlan Scruggs and Julia Hooks worked together to organize the city's juvenile court system. Julia Hooks, known to many in the community as the "Angel of Beale Street," worked to improve the living conditions of the African-American community. Memphis also had activists working to support the rights of women, beginning with the city's first suffrage organization in 1889. The city also worked to ensure that citizens had safe, affordable housing. In the late 1930s, construction began on several housing projects, including the Dixie Homes and LeMoyne Gardens Housing Projects, which served the African-American community, and Lauderdale Courts and Lamar Terrace, which served white residents.

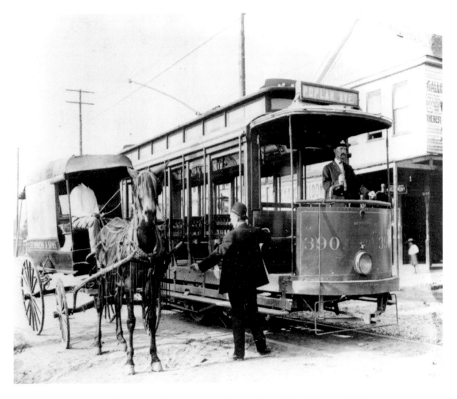

Electric trolley cars often shared the streets with carriages. The Memphis Streetcar Company used mule cars until 1890.

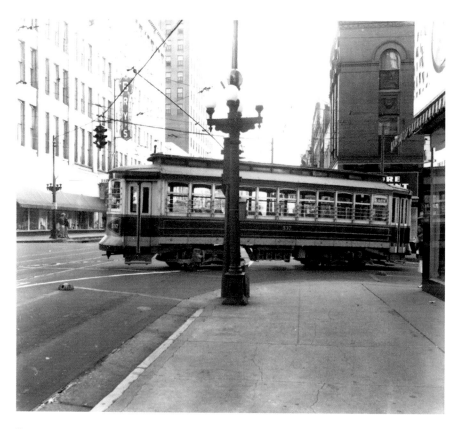

Streetcars were a common sight on Main Street. May 1940.

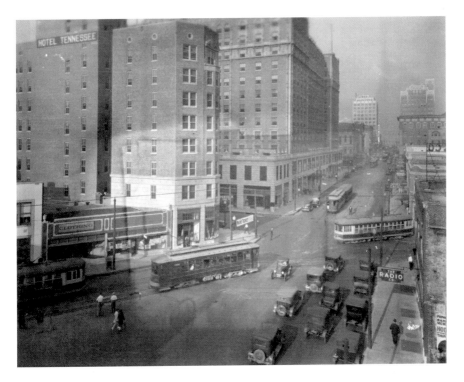

Trolley cars once traveled Union Avenue.

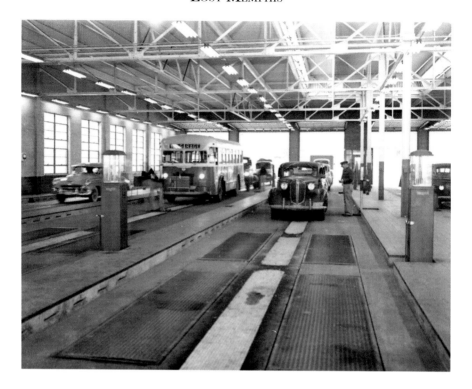

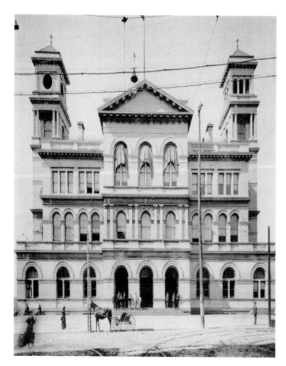

Above: Memphis became the first city in the country to create a mandatory motor vehicle inspection bureau. The National Safety Council awarded Memphis the title "Nation's Safest City" in 1937, and again in 1941, because of this distinction.

Left: The United States Customs House on Front Street bestowed a grand impression on visitors arriving in the city by riverboat. The building later served as a courthouse, a post office, and the University of Memphis School of Law. 1895.

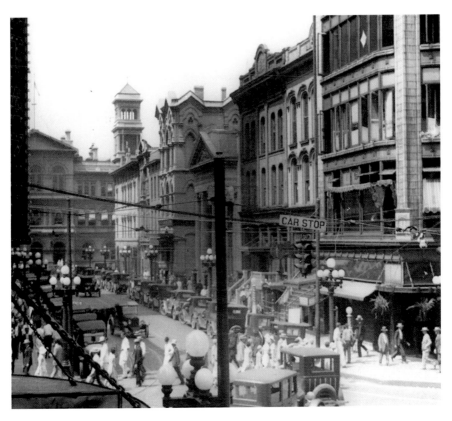

The United States Customs House can be seen at the northern end of Madison Avenue. 1927.

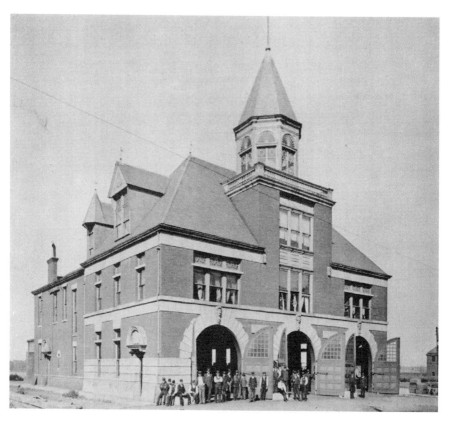

The Memphis Fire Department headquarters, located at the corner of Front Street and Union Avenue. 1895.

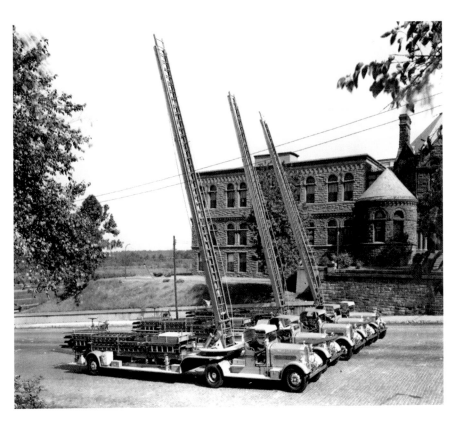

The Memphis Fire Department displayed its trucks in front of Cossitt Library.

Left: The Memphis Police Department headquarters, located at 128 Adams Avenue, opened in 1911.

Below: Built in 1893, the Cossitt Library was the first free public library in the city.

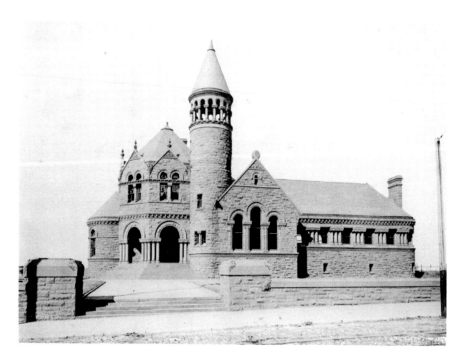

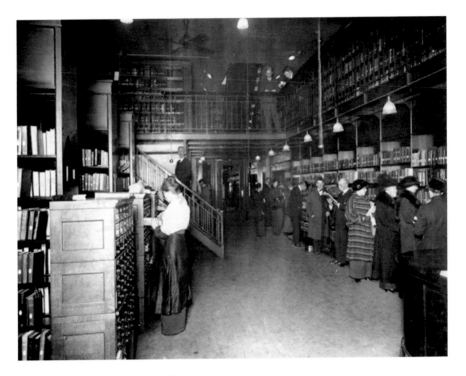

An interior view of the original Cossitt Library.

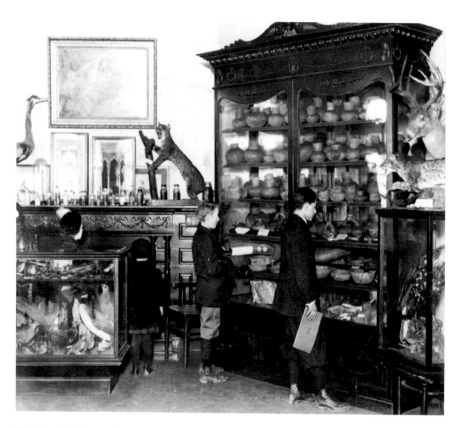

The Cossitt Library also housed one of Memphis's first museums.

The Main Library on Peabody Avenue served the Memphis community for nearly fifty years. 1970s.

Memphians loved the Memphis and Shelby County Room at the Main Library on Peabody Avenue. The light fixtures and chairs came from the original Holiday Inn on Summer Avenue.

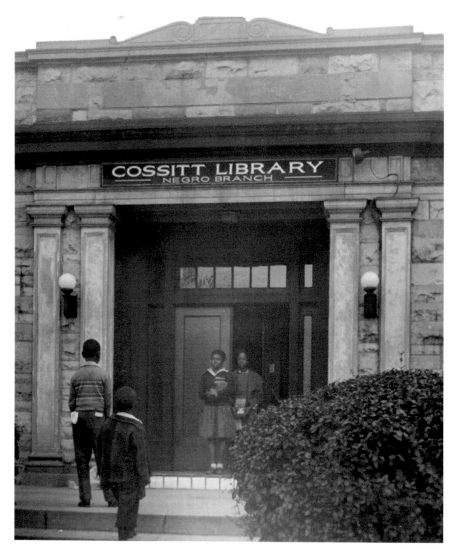

The Cornelia Crenshaw Branch Library replaced the Cossit Library–Negro Branch after it burned down in 1978 during the first night of the Memphis fire- and policemen strike.

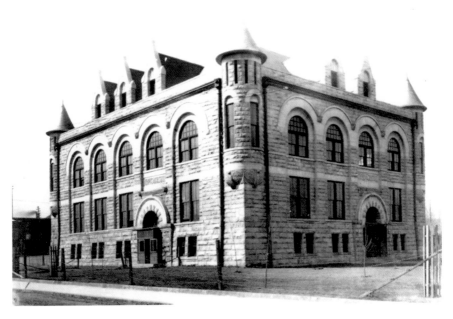

Memphis High School was the first public high school in the city.

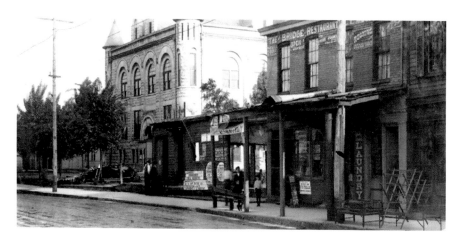

Memphis High School (left) was located on Poplar Avenue near present-day Danny Thomas Boulevard.

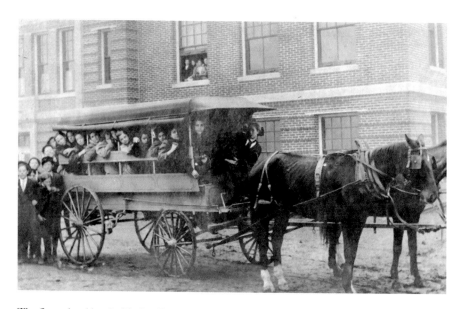

The first school bus in Shelby County carried students to Messick School, named in honor of Superintendent Elizabeth Messick.

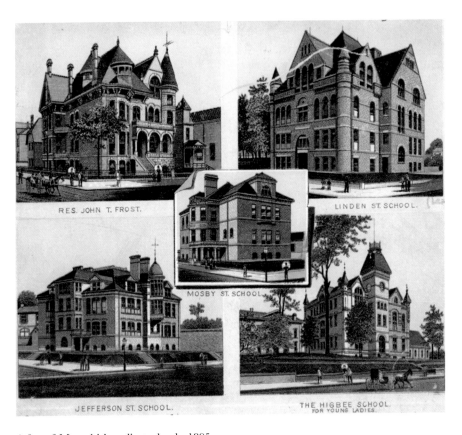

A few of Memphis's earliest schools. 1895.

In 1871, events at Brinkley Female College, a private school for young girls, brought Memphis to a standstill when reports of a ghost sighting spread throughout the city.

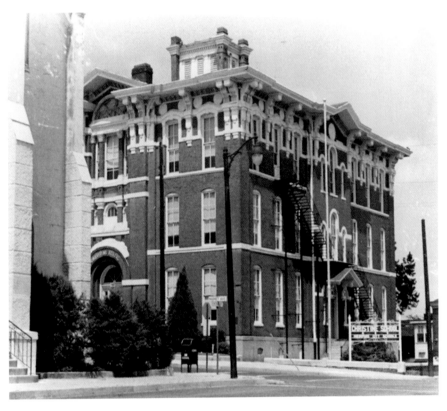

Built in 1872, Market Street School, later renamed Christine School, closed in 1964.

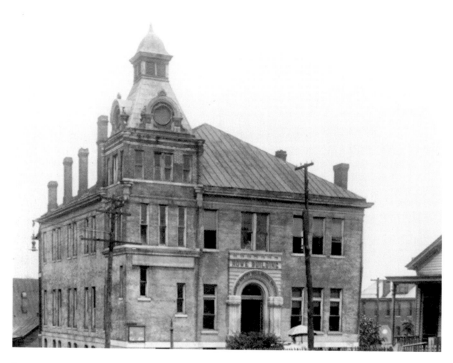

Howe Institute was one of the earliest education facilities for African Americans in Memphis.

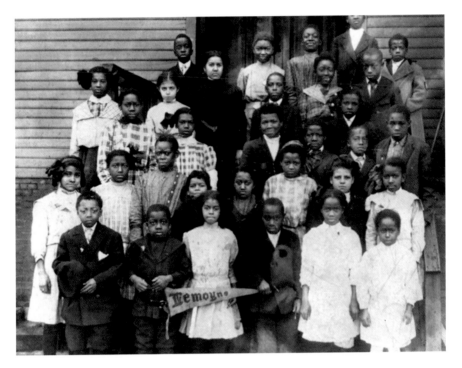

LeMoyne Normal and Commercial School opened in 1871.

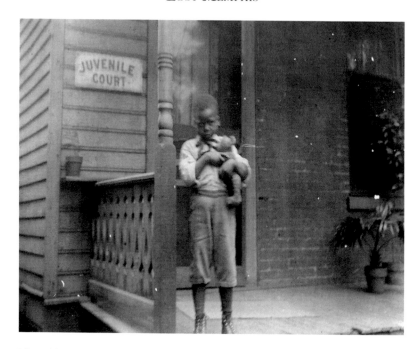

Memphis once maintained two separate juvenile courts for white and African-American offenders.

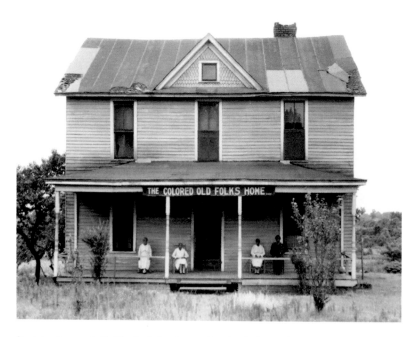

Social reformer Julia Hooks helped organize the Colored Old Folks Home, then located on Hernando Road.

Serving the Public

Right: Suffragettes proudly displayed their "Votes for Women" signs in a parade on Main Street. Circa 1919.

Below: Memphian Lide Meriwether founded Tennessee's first women's suffrage organization in 1889.

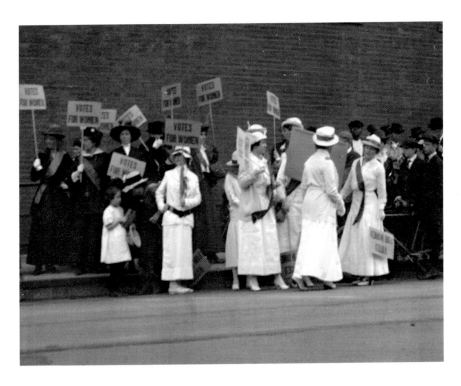

The 633-unit Dixie Homes Public Housing Project was one of the first federal housing projects completed in Memphis. 1938.

LeMoyne Gardens Public Housing Project opened in 1939.

CORNER SHOPS AND
MOM AND POPS

DOING BUSINESS IN MEMPHIS

S everal enterprising businessmen had their start in Memphis. In the
1930s, J.C. Stedman, a builder from Houston, Texas, began constructing
small houses that were used for floral shops, delicatessens and other small
businesses. He later put a restaurant in one of the small structures, which
led to the development of a restaurant chain known as Toddle House. The
small houses were built on leased land and designed to be easily transported.
Stedman named his restaurant after someone noticed that the house
"toddled" as it was being moved on a flatbed truck. Stedman moved to
Memphis and built the city's first Toddle House on South Cleveland Avenue.
Fred Smith Sr., father of Fred Smith Jr., the founder of Federal Express,
served as the first president of the Toddle House Corporation.

The restaurants had no tables, only a counter and ten stools. Customers
paid their checks by dropping the correct amount of money in a box by
the door. A similar chain, Dobbs House, competed with the company until
Dobbs purchased the Toddle House Corporation in 1962. In segregated
Memphis, African Americans were refused service at many restaurants. As
an alternative, the owners of Toddle House began operating Harlem House,
a similar chain of restaurants for African Americans.

Memphis was also home to entrepreneur Clarence Saunders, developer
of the self-service grocery store concept. Saunders felt a self-service store
that offered the customer choices and followed a strictly cash-and-carry
policy would be successful. This store, which he called Piggly Wiggly, opened
in September 1916 at 79 Jefferson Avenue. By 1922, Saunders owned 650 of

the 1,200 Piggly Wiggly franchises in the United States, worth an estimated $10 million. By 1923, Saunders faced serious financial trouble due to his investment in Piggly Wiggly stock. In August 1923, he resigned as president of his company, turned over his stock in the grocery chain and was forced to hand over the estate he had been building in Memphis. Today, this large estate is known as the Pink Palace Museum.

His first failure did not stop Saunders from entering the grocery business again. He soon borrowed money and opened a chain of stores called Clarence Saunders, Sole Owner of My Name. These stores failed during the Great Depression. Saunders tried once again with a store he called Keedoozle, which stood for "key does all." This new, automated store worked by allowing customers to select grocery items they wished to purchase using a key given to them at the front of the store. When they finished making selections, the cashier inserted the key into a master hole, which dropped the customer's groceries onto a conveyor belt leading to the front of the store. The last of Saunders's Keedoozles, located in a Quonset hut at the corner of Poplar Avenue and Union Extended, opened in 1948 and closed the following year. The City of Memphis purchased the building and relocated it to the Mid-South Fairgrounds, where it was demolished in 2008 following decades of multipurpose use.

Other pioneering companies in Memphis included Fortune's Incorporated and Holiday Inn. In 1883, T.P. Fortune established the Fortune Ward Drug Company at the Hotel Gayoso, later moving to a storefront on Main Street, followed by a location on Madison Avenue. In 1906, Harold Fortune, the founder's son, noticed customers ordering drinks and taking them back to their carriages, unable to find a seat in the store. Fortune then began posting employees outside to serve customers as they drove up to the building. The concept proved successful, and the company expanded its interests into several eateries and an ice cream manufacturing firm.

Kemmons Wilson developed the concept for the hotel chain Holiday Inn following a disappointing experience on a family road trip. Wilson was frustrated by the low quality and inconsistency of the motels his family occupied. Wilson felt a family-friendly hotel chain, easily accessible to travelers, with standardized and clean facilities would prove successful. In 1953, the first four hotels opened in Memphis, one adjacent to each major thoroughfare entering the city. Wilson later franchised the chain, and within five years, over fifty hotels were located across the country. In 1961, Allen Gary, who sat on the board of directors for Holiday Inn, opened the Admiral Benbow on Union Avenue, the first motel in the city to have more than one floor.

Corner Shops and Mom and Pops

With renovations in buildings and advancements in transportation, nothing in Memphis has changed quite so dramatically as downtown. Until the mid-twentieth century, nearly all commercial businesses were located downtown. Front Street had the cotton trade, Madison Avenue served as the city's banking and financial district, while Main Street was lined with retail stores. Department stores such as Goldsmith's, John Gerber Company and Bry's anchored the street's retail shopping district. Main Street was seen by many to be the heart of the city, and because of this it was also the scene for political activism.

African Americans were originally excluded from Memphis's main business district. As a result, Beale Street emerged as the business, cultural and political center for the African-American community. The street changed dramatically over time. In the city's early history, large mansions lined the street to the east. The commercial district was located closer to downtown. A market, dry goods stores and other retail establishments lined the street. A. Schwab's dry goods store is the only remaining original business on Beale Street. At night, the street came to life with nightclubs, theatres and restaurants. Music filled the air while vice filled the streets. In 1969, the city began various urban renewal projects in the vicinity of Beale Street; all housing was removed, and nearly five hundred buildings were torn down. Despite later preservation efforts, Beale Street remains a mere glimpse of its former heyday.

The popularity of downtown began a slow decline after World War II that accelerated in the 1960s and 1970s. Department stores and businesses began to relocate farther east, a trend that led to the growth and development of neighborhood convenience stores, restaurants and shopping centers.

Dobbs House Luau, once located on Poplar Avenue, offered diners a night in tropical paradise. The Polynesian-themed restaurant opened in 1959 and closed in 1982.

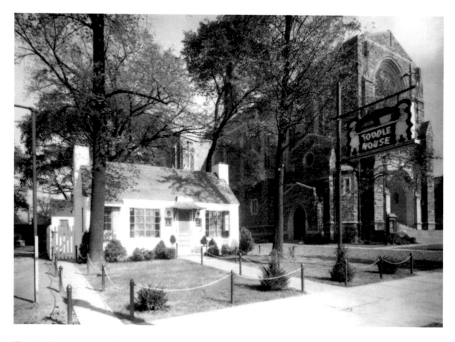

Toddle House opened in 1931. The small restaurants specialized in breakfast and were open twenty-four hours a day, seven days a week. 1937.

Corner Shops and Mom and Pops

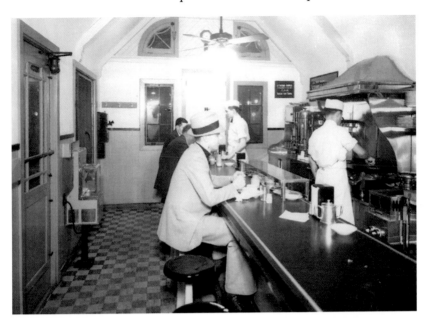

Due to their small size, Toddle Houses had no tables, only a counter and ten stools.

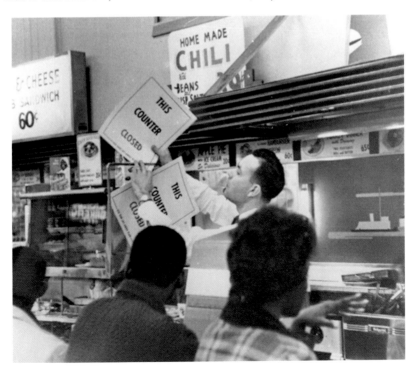

Students from both LeMoyne and Owen Colleges conducted the first Memphis lunch counter sit-in at McLellan's on Main Street on March 18, 1960.

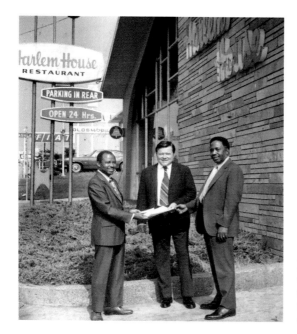

Harlem House operated under the same management as Toddle House but catered to the African-American community. 1972.

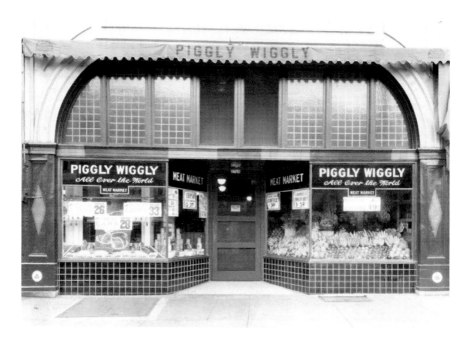

On September 6, 1916, Clarence Saunders opened Piggly Wiggly, the first self-service grocery store, at 79 Jefferson Avenue.

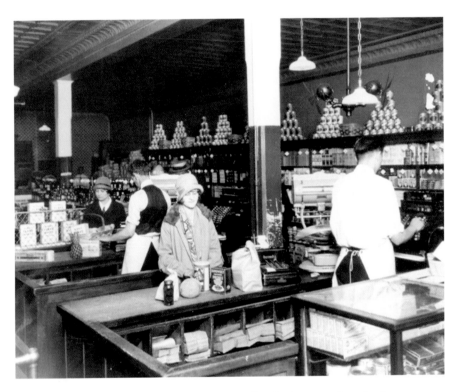

Piggly Wiggly became the first grocery store to offer checkout stands and price tags on every item.

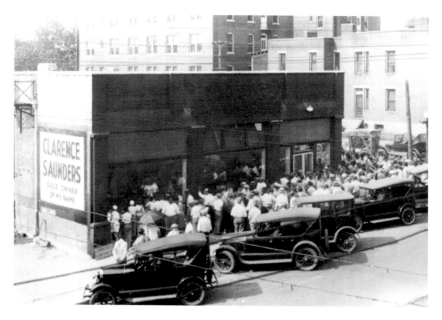

Clarence Saunders's second grocery chain was called Clarence Saunders, Sole Owner of My Name.

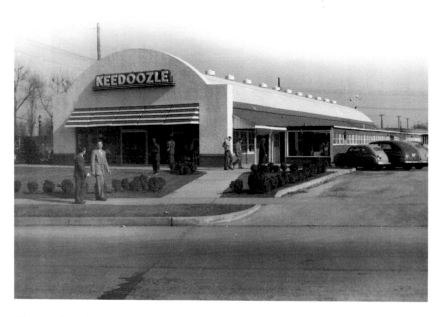

Clarence Saunders also developed Keedoozle, an automated grocery store whose name meant "key does all." The last Keedoozle opened in 1948 at the corner of Poplar Avenue and Union Extended.

Corner Shops and Mom and Pops

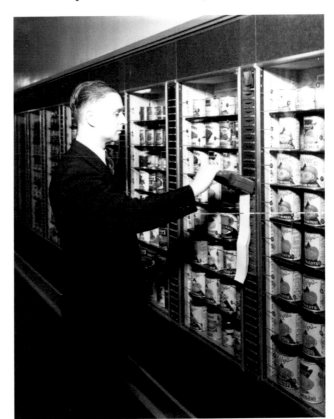

Right: Keedoozle customers used a key to select merchandise behind glass window displays. Later, the items dropped onto a conveyor belt leading to a checkout station.

Below: Clarence Saunders named one of his homes Annswood, which later became the Lichterman Nature Center. A fire destroyed the wooden cabin in 1994.

Fortune's Ice Cream Company proudly claimed the first curbside and drive-in service in the country. 1939.

In 1986, former Australian prime minister Malcolm Fraser appeared in the lobby of the Admiral Benbow Inn wearing only a towel and confused on the whereabouts of his pants. The incident became known in Australia as the Memphis Trouser Affair.

Corner Shops and Mom and Pops

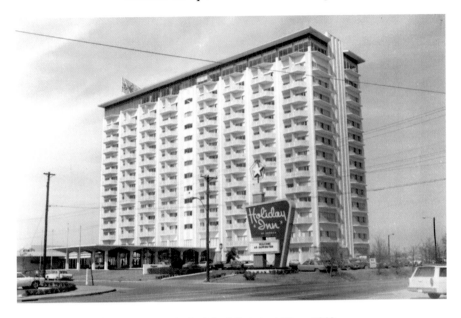

The Holiday Inn–Rivermont overlooked the Mississippi River. 1968.

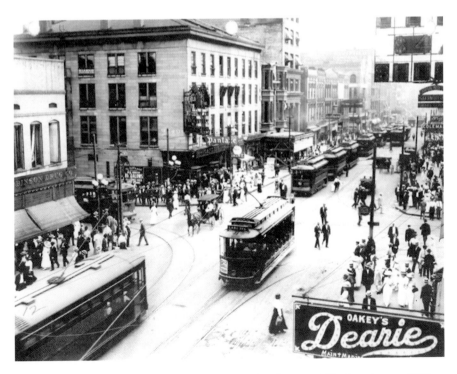

Memphis's busiest intersection was at the corner of Main Street and Madison Avenue. 1912.

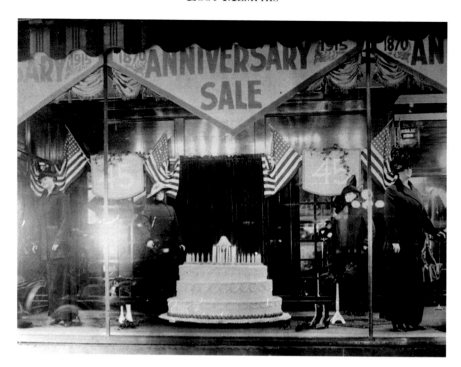

Goldsmith's Department Store, a Memphis favorite, covered an entire city block at the south end of Main Street's shopping district. This window display celebrates the store's forty-fifth anniversary in 1915.

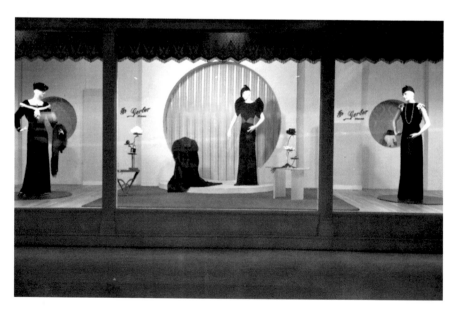

The John Gerber Company Department Store sold high-end apparel on Main Street. 1933.

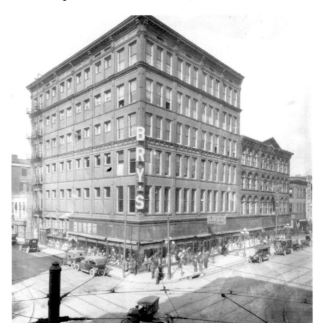

Right: Bry's Department Store, located at Main Street and Jefferson Avenue, was one of the South's largest department stores. 1918.

Below: Lowenstein's Department Stores eventually purchased the Bry's Department Store chain. 1936.

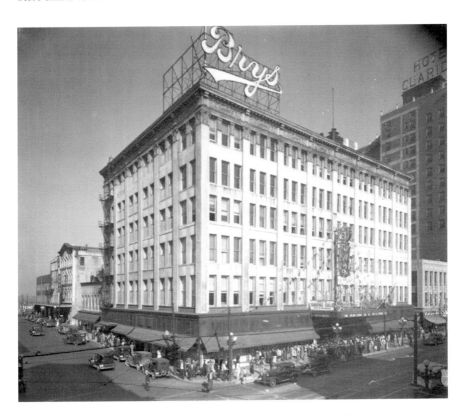

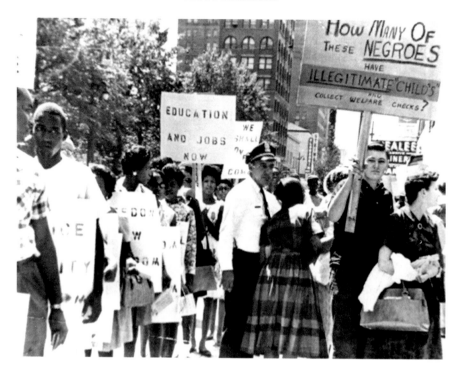

Protesters and counter-protesters demonstrated in Court Square on Main Street.

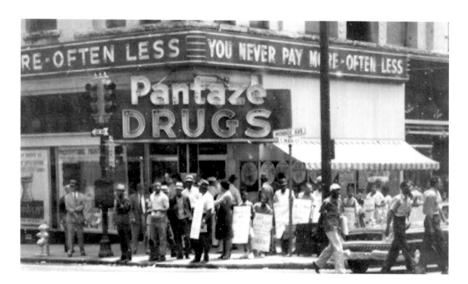

A boycott also took place at Pantaze Drugs at the corner of Main Street and Monroe Avenue.

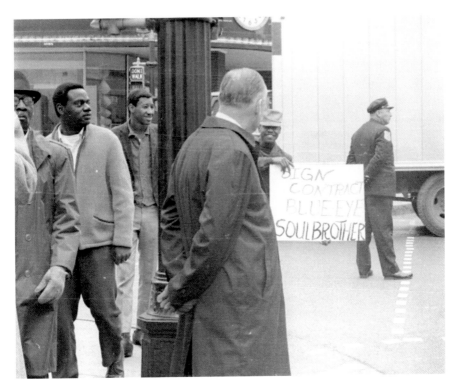

Striking sanitation workers marched down Main Street on February 26, 1968.

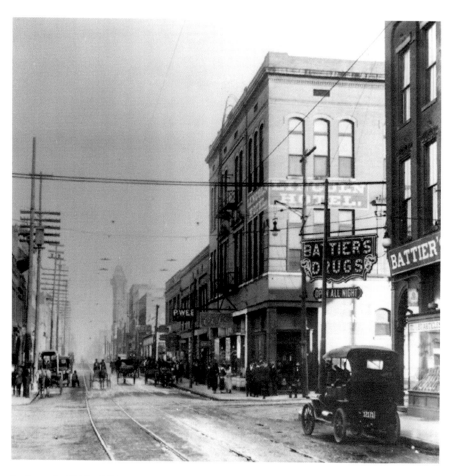

In the early 1900s, African Americans and immigrants owned almost all commercial businesses on Beale Street. 1915.

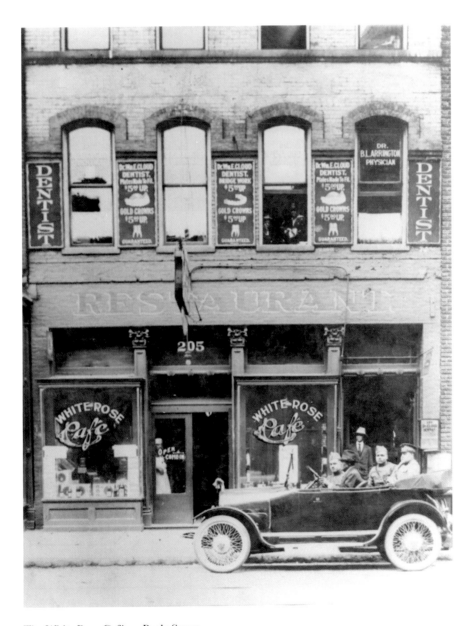

The White Rose Café on Beale Street.

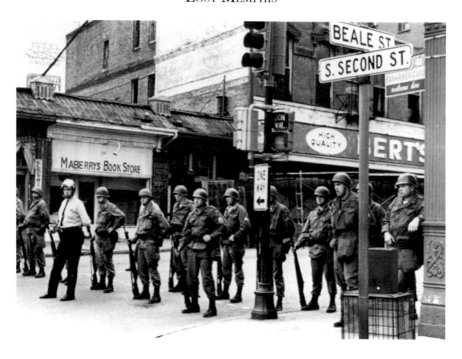

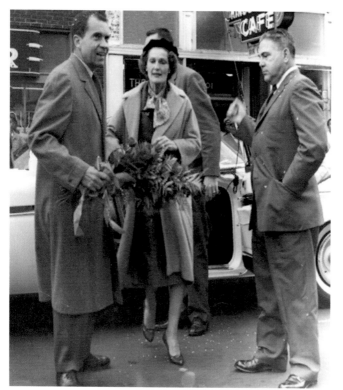

Above: Members of the National Guard lined Beale Street following the 1968 assassination of Dr. Martin Luther King Jr.

Left: During the Memphis stop of his presidential campaign, Richard Nixon laid a wreath at the W.C. Handy statue on Beale Street. King's Café can be seen in the background. 1960.

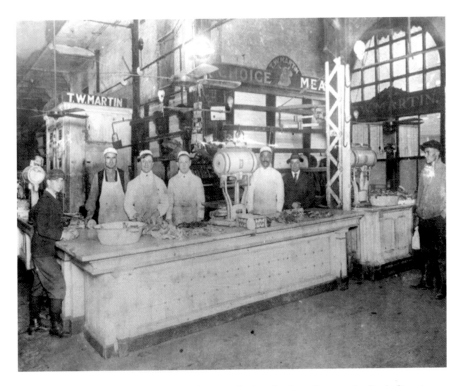

Customers purchased meats, fresh produce, and other food products at the Beale Street Market. After the market closed in 1928, the site became W.C. Handy Park. 1919.

Founded in 1876 by Abraham Schwab, A. Schwab's became the most prosperous dry goods store on Beale Street.

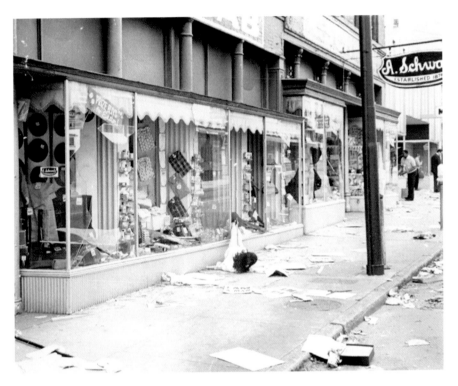

Garbage, glass, merchandise and a mannequin were left on A. Schwab's sidewalk in the aftermath of a riot following a march for striking sanitation workers led by Martin Luther King Jr. on March 28, 1968.

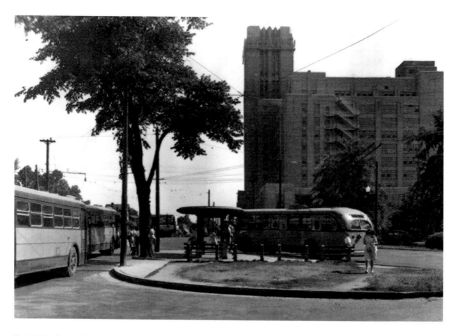

In 1927, Sears Department Store opened on Cleveland Street, becoming the first major department store to open outside downtown.

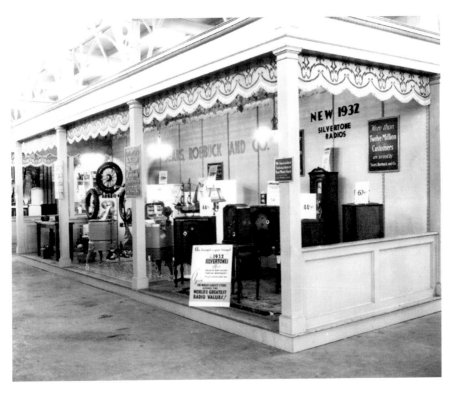

Sears, Roebuck and Company exhibited new Silvertone radios at the Mid-South Fair. 1932.

Boone's Café was located at Georgia Avenue and Orleans Street. 1943.

The intersection of Poplar Avenue and Highland Street would eventually be home to Poplar Plaza, the first shopping center located outside of downtown. 1945.

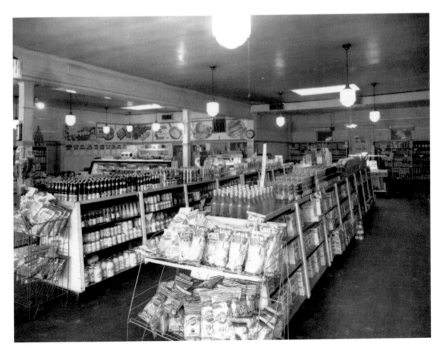

This corner Weona Food Store, number twenty-five in the chain, was located on Netherwood Avenue. March 11, 1949.

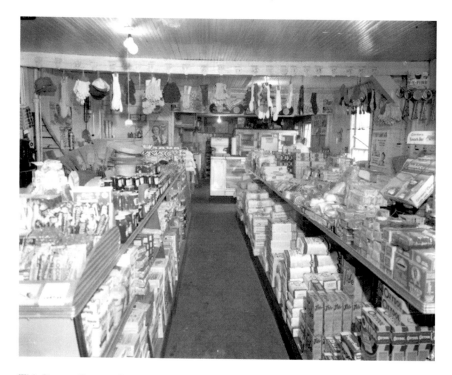

This Bomar Grocery Store was located on Chelsea Avenue. 1950.

In 1951, Julius Lewis opened an east location at the corner of Union Avenue and McNeil Street.

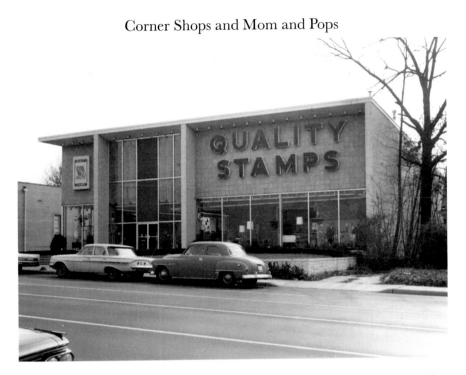

Trading stamps from Memphis-based Quality Stamps could be exchanged for merchandise at this redemption center on Union Avenue. 1963.

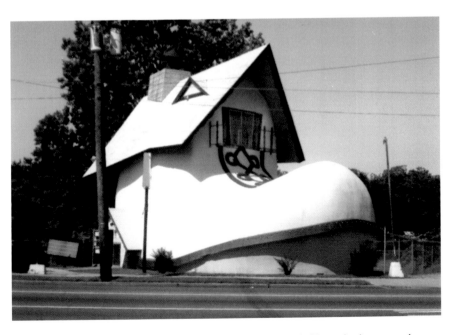

In 1965, architect Lawrence T. Hord Jr. designed the Memphis Shoe, also known as the Enchanted Shoe, located on Lamar Avenue. 1990.

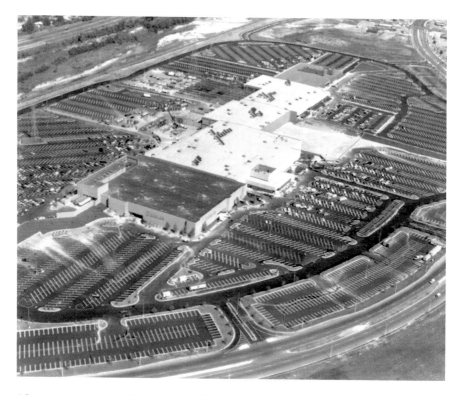

After twenty-two years of business, the Mall of Memphis closed on Christmas Eve 2003.

ENTERTAINMENTS AND
AMUSEMENTS

Memphians have always enjoyed a wide variety of sports, parks, fairs and other amusements. Horse racing was one of Memphis's earliest and most popular sporting events. The North Memphis Driving Park, located on present-day Thomas Street, and Montgomery Park, located on the present site of the Mid-South Fairgrounds, were the most popular racing facilities in the city. In 1905, the Tennessee legislature passed a law prohibiting gambling on races, effectively putting an end to horse racing in Memphis.

Football has been played in Memphis since the late 1800s. The University of Tennessee College of Medicine "Docs" football team brought college football to Memphis. The Docs played in the outfield of Russwood Park baseball stadium. The team disbanded in 1926 after only six seasons. Crump Stadium, built adjacent to Central High School, provided an impressive facility for area football. In 2006, it was replaced by a smaller facility, better suited for high school football games.

Baseball in Memphis dated back to the 1860s. Memphis has been the home to several baseball teams including the Memphis Red Sox, the Turtles, the Chicks and the Redbirds. The Memphis Red Sox, a professional Negro League baseball team owned by brothers J.B. and B.B. Martin, played at Martin Park on Crump Boulevard. In 1899, an amateur baseball team also known as the Red Sox built Red Elm Park in an area of Memphis known as Red Elm Bottoms. After Memphis joined the Southern Association in 1901, Red Elm became Memphis's home park. In 1914, the park's name changed

to Russwood. The stadium remained the home for Memphis baseball until it was destroyed by fire in 1960.

In 1912, Robert Galloway told the mayor and city commissioners, "Parks are the people's best friends." Galloway, chairman of the Board of Park Commissioners, felt that public parks gave the city "refinement, freshness, and beauty," while providing citizens with "pleasure, comfort, and contentment." The three founders of Memphis—James Winchester, John Overton and Andrew Jackson—also believed in the necessity of parks and public lands for the benefit of the city. By setting aside land for public squares and a promenade, the three men essentially created Memphis's first park system. One of the public squares, Market, later became Brinkley Park. The children in the area often played in the Gayoso Bayou, in unsafe and unsanitary conditions. A playground gave the children a relatively safe alternative. Over the next decades, the city acquired few additions to its parkland. One of the first additions was land used for Memphis City Hospital, which occupied the site from 1848 until 1898. After the hospital relocated, the land was renamed Forrest Park, in honor of General Nathan Bedford Forrest.

In 1900, the city established the Memphis Park Commission. The Park Commission acquired and developed new parklands and incorporated them into a centralized park system, along with previously established parks. One of the commission's first tasks included hiring landscape architect George Kessler. Kessler began by designing Riverside and Overton Parks, which he connected with two tree-lined boulevards, South Parkway and East Parkway. At the time, Overton Park was located on the eastern limits of the city in an area known as Lea's Woods. The land for Overton Park once belonged to city founder John Overton and had been willed to his grandson, Overton Lea.

Over time, the Park Commission also acquired private parks. In 1913, the city purchased Jackson Mound Park, renaming it De Soto Park, in honor of Hernando De Soto. The site was once the Chickasaw village of Chisca. During the Civil War, the site was also part of Fort Pickering. Soldiers used the largest earthen mound as an artillery redoubt and magazine. Ammunition was stored in a bricked bunker, dug into the mound's side.

In 1899, Robert R. Church Sr. purchased land on Beale Street for the development of a six-acre park for Memphis's African-American citizens. In addition to landscaped gardens, the park featured an auditorium with a seating capacity of two thousand. In 1941, the city acquired the park and removed the Church name. Although the park's name was restored fifteen

years later, the auditorium has since been destroyed. A 1963 Supreme Court ruling opened Memphis's parks to all citizens.

In addition to traditional parks, Memphians also enjoyed other outdoor recreational facilities. In 1889, the East End Streetcar Line opened East End Park, a mile and a half outside the city limits, near the present-day intersection of Madison Avenue and Morrison Street. The East End Line ran to nearby Montgomery Park, and a second entertainment venue in the vicinity ensured that Memphians would take advantage of the line year round. When the park opened, it was a simple place for Memphians to fish in a bayou. Over time, East End created a lake by damming the bayou and offered small rowboats to rent. The park later featured a midway, rides, a dance pavilion and vaudeville shows. There is some debate in the community regarding East End's rollercoaster. After the park closed in 1913, many Memphians believe the coaster was rebuilt at the fairgrounds. However, others dispute this claim, instead believing that East End's coaster was destroyed in a fire and a completely new ride was built at the fairgrounds.

The city's fairgrounds were built on land previously occupied by Montgomery Park. In 1882, Henry Montgomery purchased land owned by the New Memphis Jockey Club, renaming it Montgomery Park. Over time, the facility expanded into one of the finest racing venues in the South. In 1912, the Memphis Park Commission purchased the land for residents to use for recreation, athletic events and fairs. By purchasing the park, the commission provided a permanent home for the Tri-State Fair, which had leased the land since 1908. In 1911, the African-American community organized the Negro Tri-State Fair, which followed the Tri-State Fair's run. In 1929, the Tri-State Fair became known as the Mid-South Fair. This allowed the Negro Tri-State Fair to drop the word "Negro" from its title. The Mid-South Fair became integrated in 1962.

In the early 1920s, the fairgrounds underwent several renovations, with the last phase completed just before the opening of the 1923 fair. The renovations included an amusement park, which featured the Grand Carousel and Pippin roller coaster. In 1963, a large entertainment arena called the Mid-South Coliseum opened at the fairgrounds. Other large performance venues in the city included Ellis Auditorium's North and South Halls.

Movie theatres have always been an extremely popular form of entertainment in Memphis. For many residents, theatres provided their only access to air conditioning—very important during Memphis's hot summers. The city's first theatres were located on Main Street. A theatre has stood on the corner at the intersection of Main and Beale Streets for over 120

years. In 1890, prominent Memphians came together and built the Grand Opera House, which offered the largest stage outside of New York City. In 1907, the theatre joined the Orpheum circuit of vaudeville shows and became known as the Orpheum. The original building burned down in 1923, and a new, larger Orpheum Theatre was built on the same site in 1928. Over time, the popularity of vaudeville faded, and in 1940, the Malco Theatre chain purchased the building for use as a movie theatre. Malco operated at the location for thirty-six years before closing its doors in 1976. The following year, the Memphis Development Foundation purchased the building, restoring it once again to the Orpheum.

The Loews Palace and Warner Theatre also operated for several decades at their downtown locations. As more businesses relocated farther east, so did the theatres. The Linden Circle, Peabody and Ritz Theatres were just a few of many neighborhood theatre houses that sprang up around the city. African Americans frequented theatres on Beale Street. Anselmo Barraso, son of Italian immigrants, operated several clubs and theatres on Beale Street that provided entertainment to the African-American community. The theatres fell into disrepair after Barraso's death in 1967. Sam Zerilla, an Italian immigrant and former clarinetist in John Phillip Sousa's band, also operated venues on Beale Street. Zerilla opened the Daisy Theatre in 1917 and its sister theatre, the New Daisy, opened across the street in the 1930s.

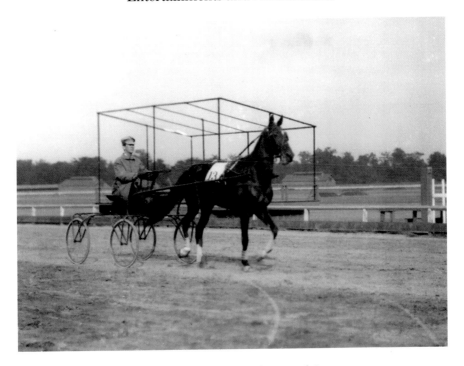

Harness racing was a popular sport in Memphis at the turn of the century.

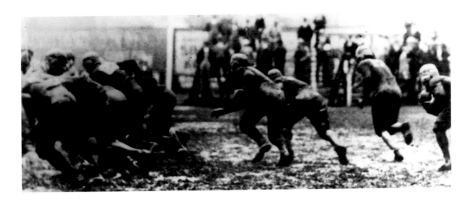

The UT Docs football team finished three seasons undefeated. 1922.

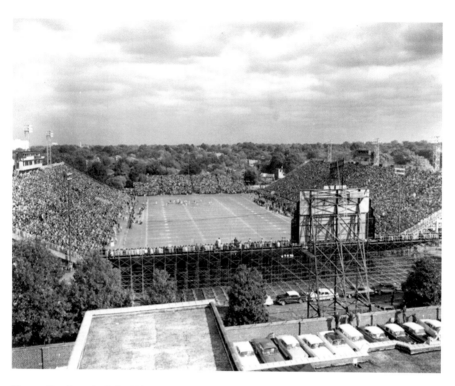

Crump Stadium, built in 1934 and expanded in 1939, featured a seating capacity of twenty-five thousand.

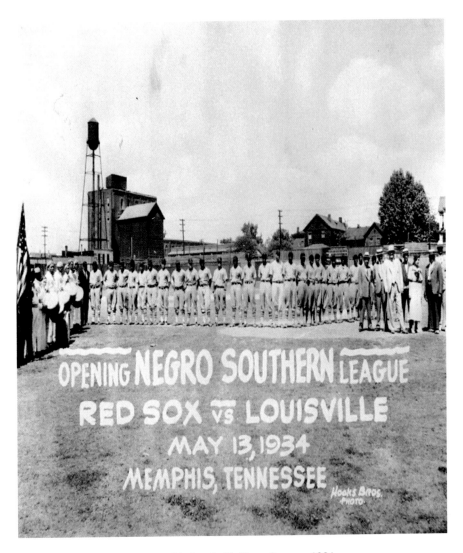

The Memphis Red Sox competed in baseball's Negro League. 1934.

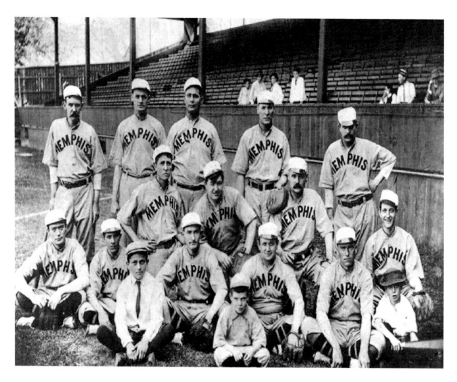

An early Memphis baseball team.

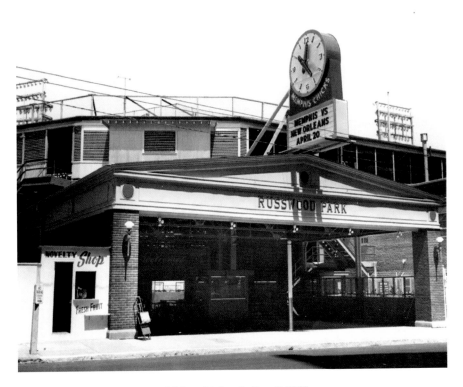

Russwood Park was the home of Memphis baseball until 1960.

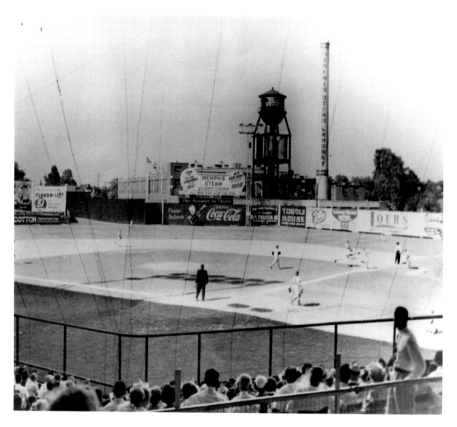

Memphis Steam Laundry's tower overlooked Russwood Park.

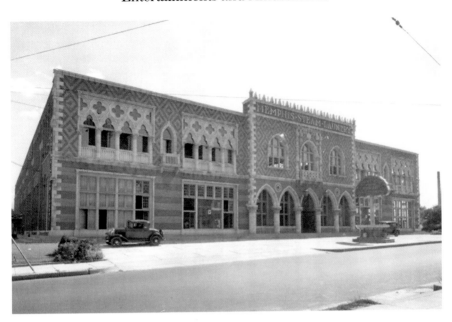

Modeled after a Venetian palace, Memphis Steam Laundry, located on Jefferson Avenue, overlooked Russwood Park.

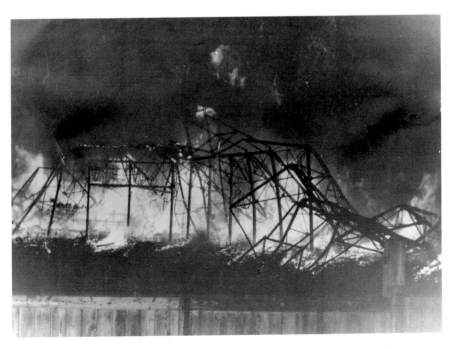

On Easter night, April 17, 1960, Russwood Park burned down during the city's first five-alarm fire.

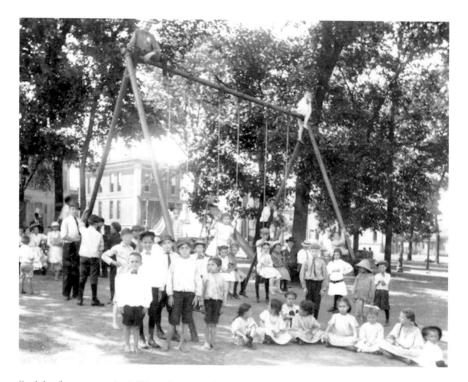

Social reformers worked diligently to provide playground equipment for impoverished children. The Market Square Playground, seen here, is now Brinkley Park. Circa 1910.

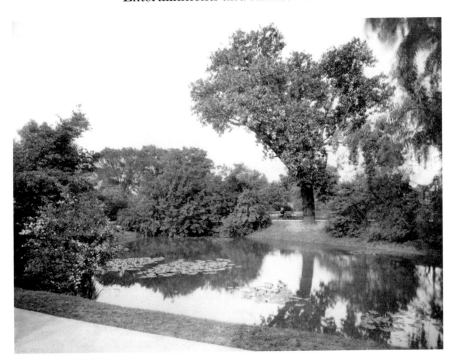

In 1941, the Memphis Park Commission converted the Forrest Park's lily pond into a garden following the drowning death of a small child. 1912.

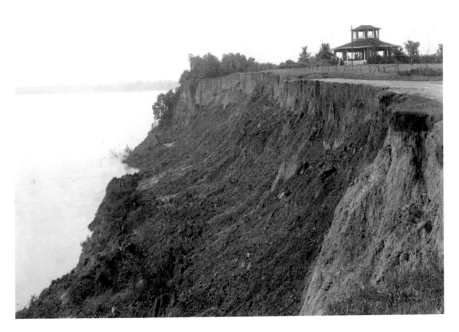

Riverside Park, later renamed in honor of Martin Luther King Jr., opened in 1903.

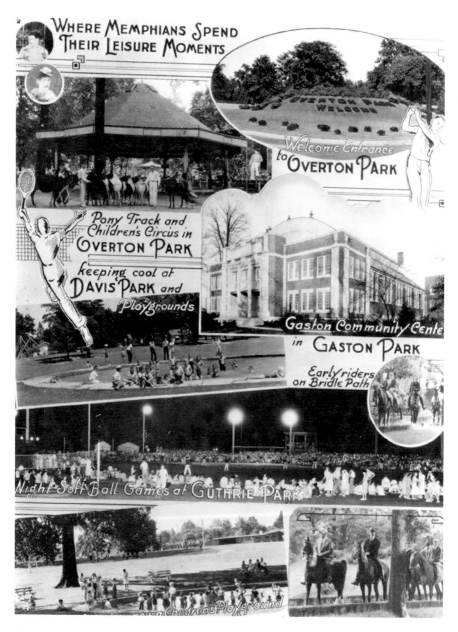

Memphians once enjoyed a variety of outdoor activities, including a Children's Circus in Overton Park, horse rides down East Parkway and a playground at Winchester Cemetery.

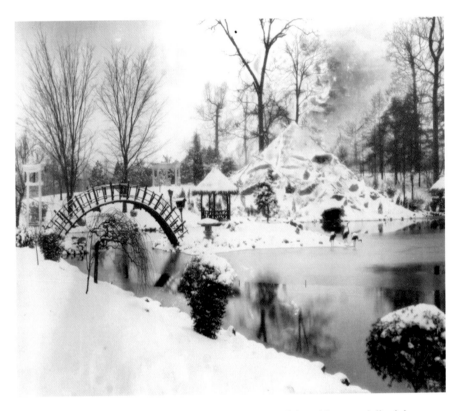

Following the Japanese attack on Pearl Harbor, distraught Memphians vandalized the Japanese Gardens in Overton Park. Within a month, the city removed the remaining structures and filled in the lake.

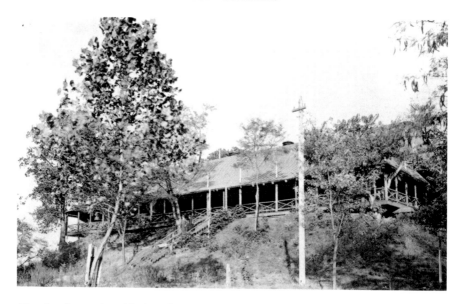

After the city purchased Jackson Mound Park, it became known as DeSoto Park and, later, Chickasaw Heritage Park. 1895.

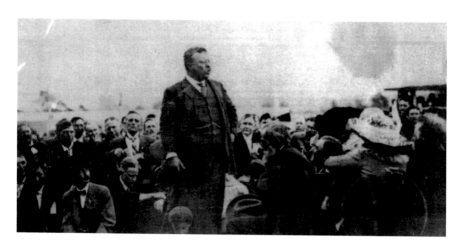

Church Park, located on Beale Street, hosted many events and prominent guests to the city, including President Theodore Roosevelt. 1902.

Entertainments and Amusements

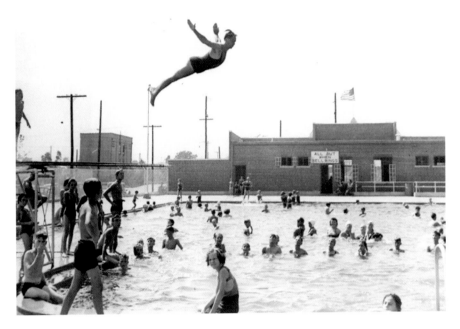

Malone Park Community Pool, located at North Main Street and Greenlaw Avenue, provided free amusement to children in the community. 1937.

Rainbow Lake Amusement Center, located on Lamar Avenue, formerly Pigeon Roost Road, included a swimming pool, a skating rink and a lounge known as the Terrace Room. 1958.

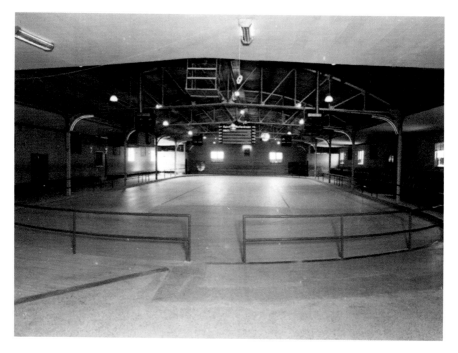

Rainbow Lake Amusement Center added its skating rink in 1942, six years after the center opened. 1958.

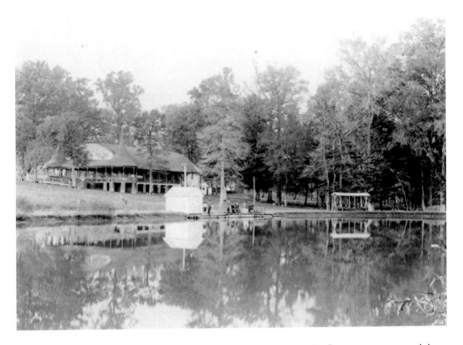

East End Park, located near present-day Overton Square, was the first amusement park in Memphis. 1895.

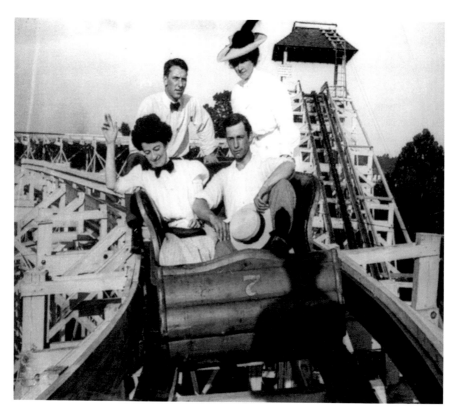

The Pippin, later renamed Zippin Pippin, was one of the oldest wooden roller coasters in the country at the time it was demolished in 2010.

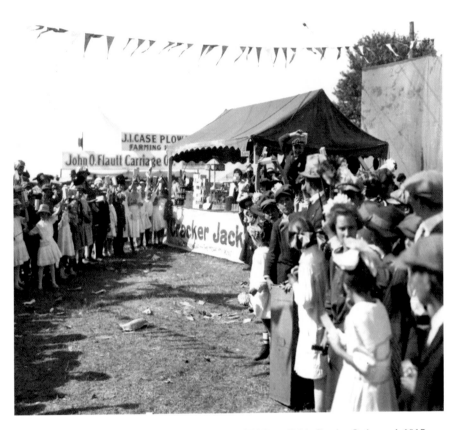

People lined up for drinks and popcorn treats at the Tri-State Fair's Cracker Jack stand. 1917.

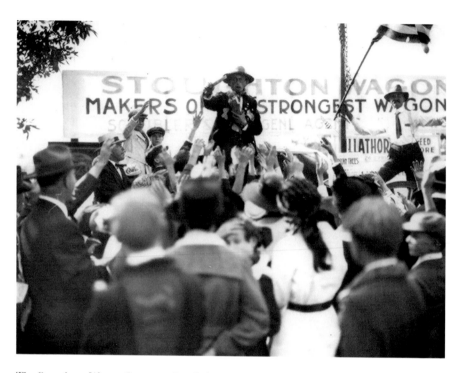

The Stoughton Wagon Company handed out rulers at the Tri-State Fair. Circa 1917.

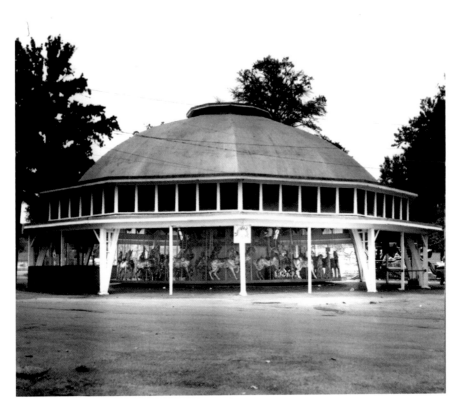

The Memphis Fairgrounds Amusement Park purchased the Grand Carousel in 1923. It was placed on the National Register of Historic Places in 1980.

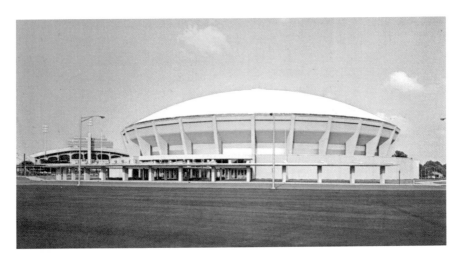

The Mid-South Coliseum, a multipurpose entertainment arena, opened in 1963 and closed in 2006.

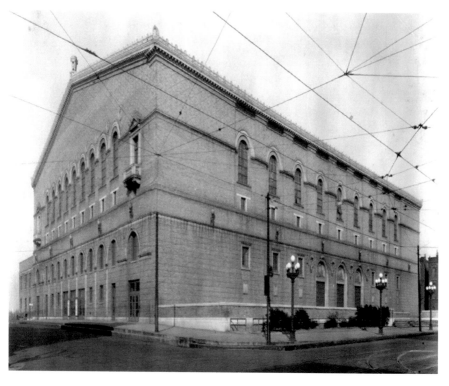

Ellis Auditorium contained two performance halls, North and South, which were separated by a curtain and shared a common stage.

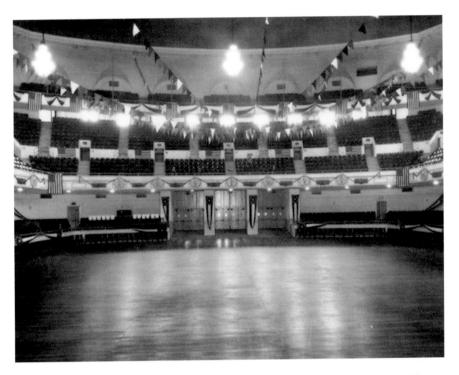

Ellis Auditorium's North Hall, the larger of the two performance halls, seated about fifty-five hundred people.

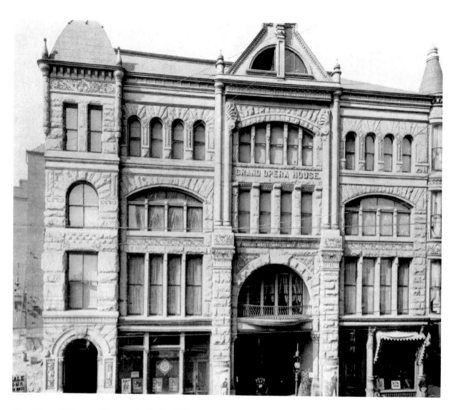

The Grand Opera House, built in 1890 at the southwest corner of Main and Beale Streets, became the predecessor to the Orpheum Theatre.

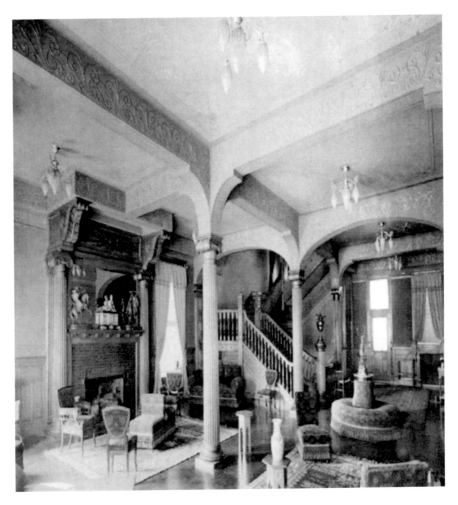

An interior view of the Grand Opera House.

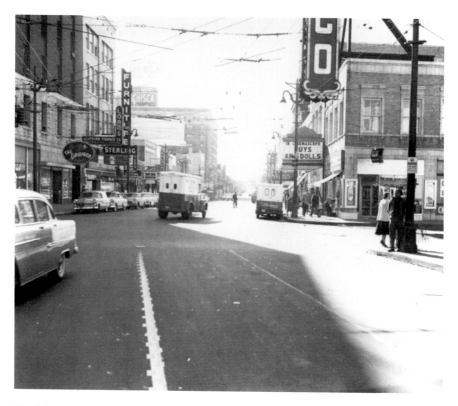

The Malco Theatre once occupied the same location as the Orpheum Theatre. 1956.

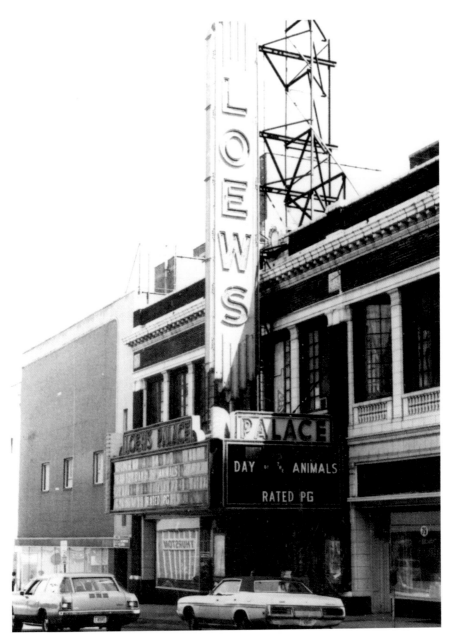

The Loews Palace Theatre closed in 1977 after fifty-seven years in operation. 1977.

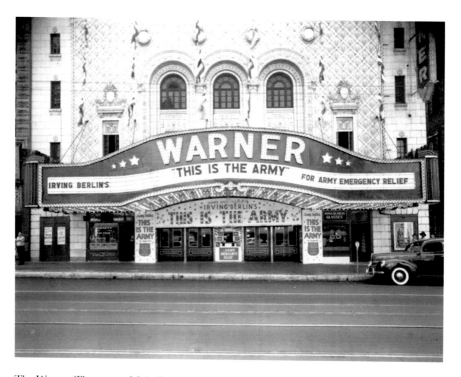

The Warner Theatre on Main Street closed in 1968 after a forty-seven-year run. 1943.

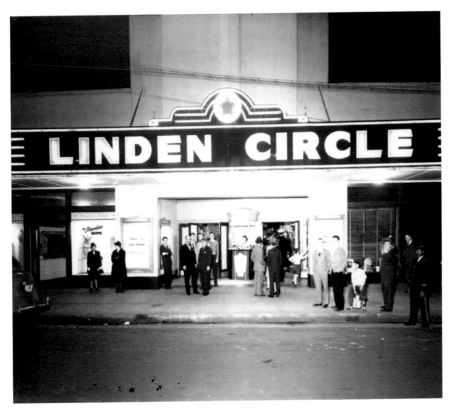

The Linden Circle Theatre opened in 1926 on South Somerville Street. 1943.

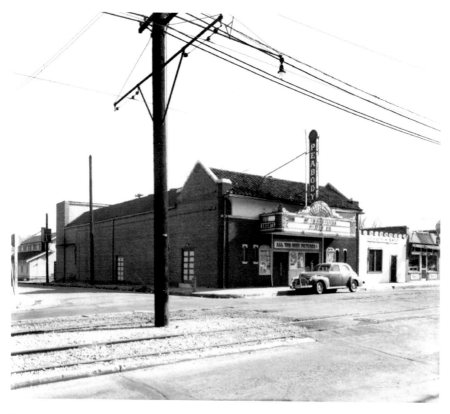

The Peabody Theatre was located at South Cooper Street and Peabody Avenue. 1948.

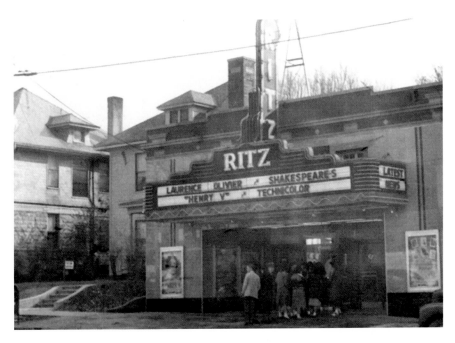

Now a live theatre venue, the Ritz Theatre on Poplar Avenue underwent several name changes, including Guild Theatre, Circuit Playhouse, and Evergreen Theatre. Circa 1946.

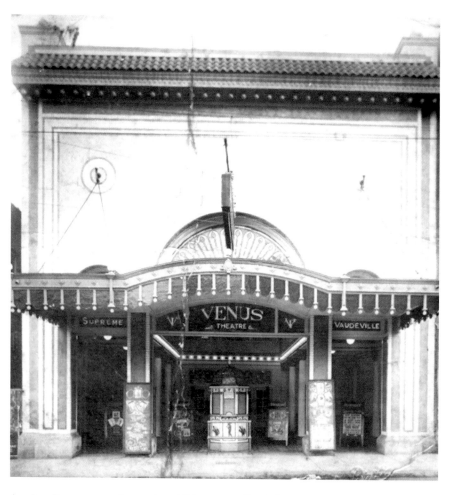

Anselmo Barraso owned several establishments on Beale Street, including the Venus Theatre, seen here.

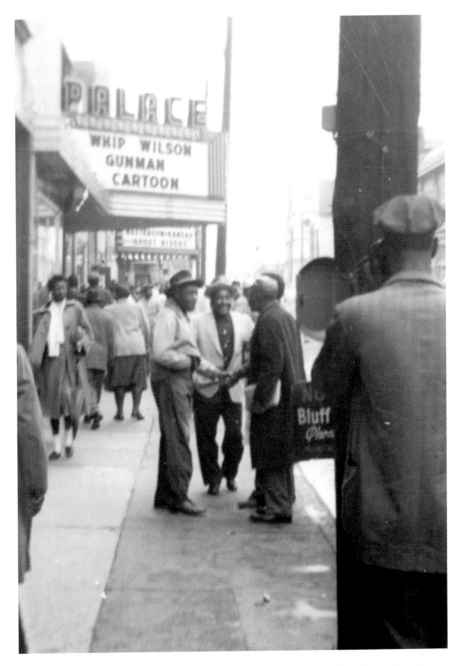

Beale Street's Palace Theatre became the top entertainment theatre for African Americans, featuring a live showcase and movies. 1955.

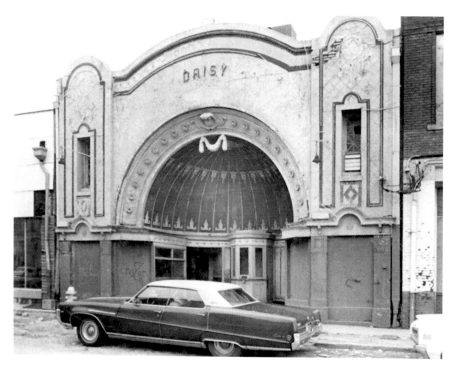

Restoration began on the Daisy Theatre in the late 1980s, and the theatre now serves as a banquet hall. 1974.

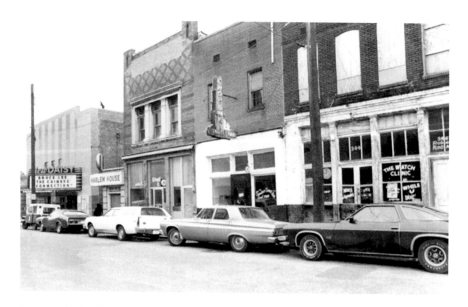

The New Daisy Theatre survived urban renewal by showing movies. 1974.

MEMPHIANS AT WAR

During the Civil War, Memphis played an important role not only as an industrial and transportation center, but also, later, as a center for illegal Confederate trade. At the start of the war, Memphians enthusiastically organized several dozen military companies, expecting a short duration of the war. In early 1862, Tennessee's state government moved to Memphis following the capture of Nashville. Memphis fell to the Union on June 6, 1862. Following the war, Memphis hosted several reunions for Confederate veterans. During the largest reunion, held in May 1901, over fifteen thousand Confederate flags decorated the city.

The outbreak of the First World War in Europe came as quite a surprise for many Memphians. By 1915, a preparedness movement had spread across the country, and Memphis was no exception. Thousands of mid-southerners marched in Memphis's preparedness parades. Once the United States entered the war, thousands of young men signed up for military service. The U.S. Navy, Marine Corps and Army took the opportunity to recruit southerners at the Tri-State Fair.

Anti-German sentiment ran high throughout the area. Schools stopped teaching German, and nearby Germantown, Tennessee, briefly changed its name to Nashoba. In November 1917, Park Field—an Army Signal Corps Aviation School—opened in nearby Millington, Tennessee. Training operations ended one year later, just two days after the signing of the Armistice in November 1918. In 1942, the U.S. Navy procured the property for a Naval Air Station.

The Second World War brought considerable change to the city. Leading into the war, Memphis experienced a period of rapid industrial growth. In 1940, Memphis became the headquarters for the Second Army. This led to other military establishments in the area, including a large army hospital on Shotwell Road. In preparation for the hospital, named in honor of Brigadier General James M. Kennedy, Memphis officials changed the street's name from Shotwell to Getwell. The Veterans Administration acquired the hospital in 1946. A separate hospital, originally operated by the Veterans Bureau, was the bureau's first general medical surgical hospital in the South.

Memphians became accustomed to seeing uniformed men throughout the city and supported the war effort with full force, donating scrap metal and purchasing war bonds. The Young Women's Christian Association and other organizations hosted special events for the troops. Memphians watched with pride as the *Memphis Belle* gained national attention. The B-17 bomber, named after the pilot's girlfriend, became the first heavy bomber to successfully complete twenty-five missions. After the war, the plane sat at Altus Air Force Base in Oklahoma, waiting to be turned into scrap. Memphis mayor Walter Chandler led the effort to purchase the plane, which the city did for the sum of $350. The plane was flown to Memphis in June 1946 and stored until the summer of 1949. At that time, the airplane went on display at the National Guard Armory on Central Avenue, where it sat exposed to the elements for nearly forty years.

In 1987, the airplane was moved to a pavilion at the Mud Island River Park. Over time, the airplane deteriorated due to vandalism and exposure. Although efforts were made to preserve the aircraft, the decision was made to move the *Memphis Belle* to the National Museum of the United States Air Force in Dayton, Ohio; this was done in 2004. A second aircraft during the war also had a Memphis connection. In 1942, Lieutenant George W. Lee led the African-American community in a war bond drive, raising enough money to purchase a B-24 Liberator, given the name *Spirit of Beale Street*.

Memphis's location on the river made it an ideal stop for postwar tours. In 1912, the USS *Petrel*, a Spanish-American War ship, visited Memphis. In 1919, crew members of the first transatlantic flight, along with two other planes, participated in a naval recruiting trip along the East Coast and Mississippi River. The men and planes drew a large crowd on their stop in Memphis. Their flight across the Atlantic in May 1919 took fifty-four hours over a twenty-three-day period; they made only six stops. Their accomplishment was overshadowed just two weeks later when two British pilots completed the first nonstop transatlantic flight. On December 23,

1945, a full-scale marine invasion of Mud Island was scheduled as part of the U.S. Navy's Hit the Beach exhibition. The event was cancelled after twenty-four airplanes were grounded due to bad weather. The invasion was replaced by an exhibition of TNT charges and a pyrotechnics display. Despite advanced notice, several Memphians notified the police, fearing the noises were from an earthquake or atomic bombs being tested in the area.

In 1962, Memphians honored the servicemen of World War II and Korea with a memorial fountain installed in front of the United States Post Office on Front Street. The memorial featured a modernistic fountain featuring a large aluminum tray and a granite basin. From the beginning, the memorial was plagued with problems. After it was unveiled, public comments ranged from "beautiful" to "horrible monstrosity." The sun's glare off the water and aluminum tray blinded postal workers, who successfully demanded that the water be shut off for five hours each workday. Memphians also began tossing various items into the fountain, including coins, dye, bubble bath and an occasional fish. On windy days, water sprayed across the sidewalk, creating a potentially icy hazard in the winter. In 1970, the Memphis Park Commission removed the aluminum basin and converted the memorial into a planter.

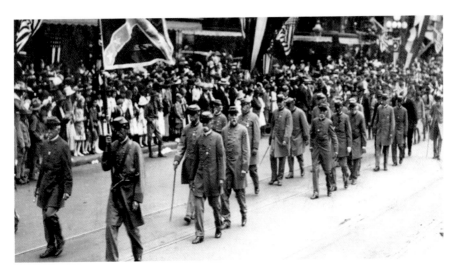

United Confederate Veterans held several reunions in Memphis. By 1942, only three Confederate veterans still lived in Memphis.

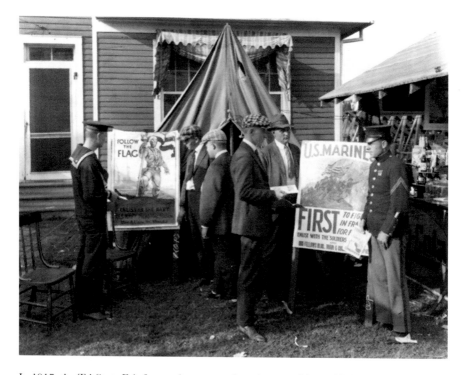

In 1917, the Tri-State Fair featured a navy and marine recruiting exhibit.

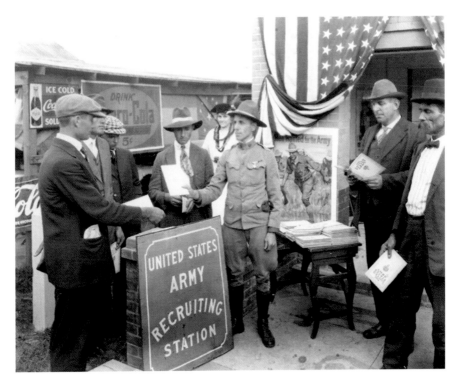

The army also recruited at the 1917 Tri-State Fair.

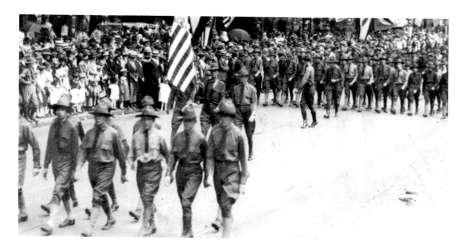

Memphis World War I veterans returned home to great fanfare in 1919.

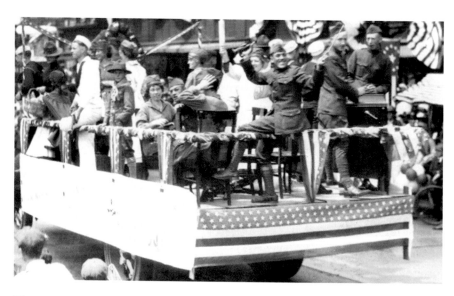

The return of World War I veterans added to the joyous atmosphere at Memphis's Centennial Celebration in May 1919.

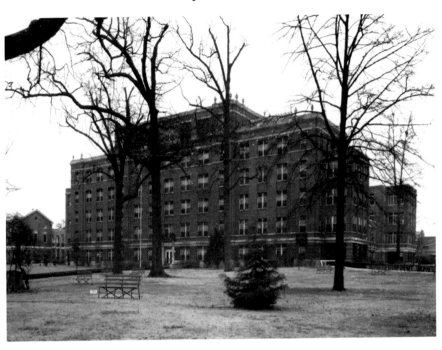

The Veterans Bureau Hospital began operating at Crump Boulevard and Lamar Avenue in 1921. The facility later became Baptist Hospital Lamar Unit.

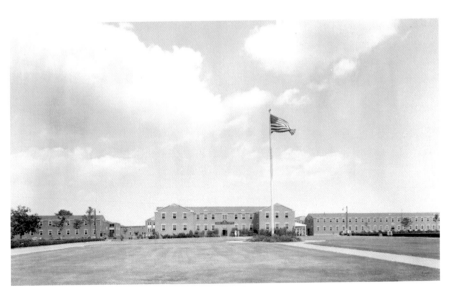

Kennedy General Hospital was one of the largest army hospitals in the United States during World War II.

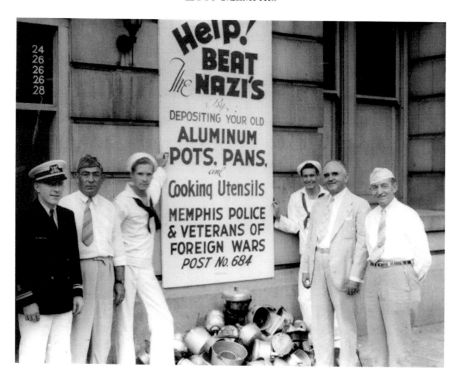

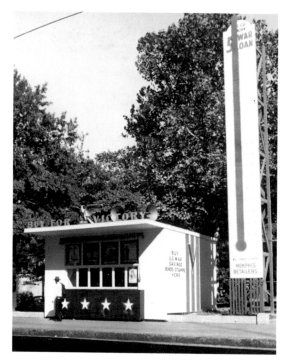

Above: Memphis mayor Walter Chandler promoted scrap metal drives during World War II.

Left: Memphians purchased war bonds at this Victory House located in Court Square.

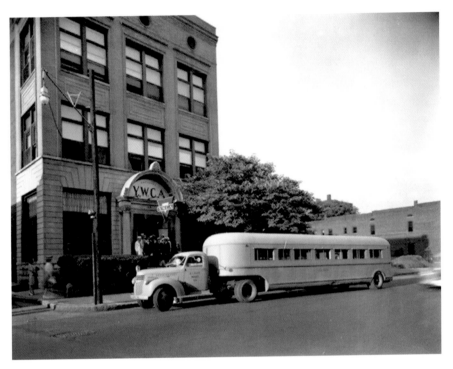

The Young Women's Christian Association, located on Monroe Avenue, hosted social events during the war. 1943.

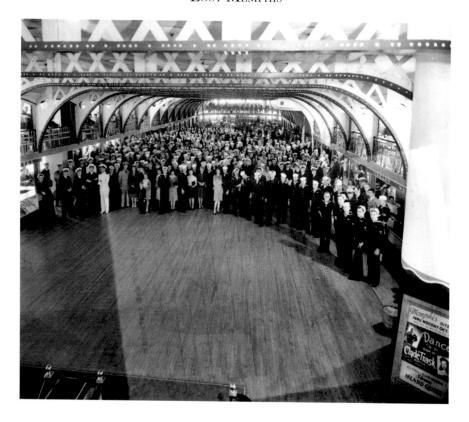

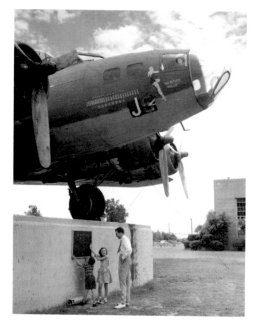

Above: Sailors danced the night away in the ballroom of the *Island Queen*, docked at the foot of Beale Street in 1943.

Left: The *Memphis Belle* sat on display at the National Guard Armory from 1949 until 1987, when it was moved to a pavilion at Mud Island River Park.

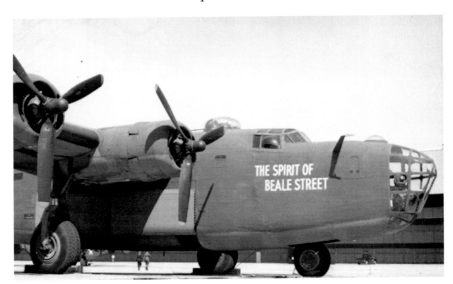

During World War II, the local African-American community purchased $302,000 in war bonds to pay for a B-24 bomber, given the name *Spirit of Beale Street*.

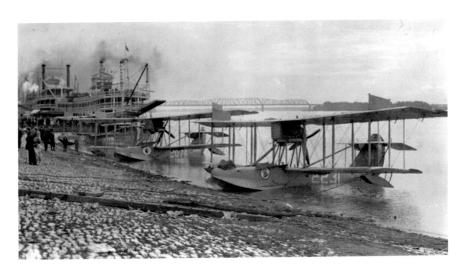

After completing the first transatlantic flight, the crew of the NC-4 (Navy Curtiss) stopped in Memphis on a naval recruiting trip on November 27, 1919.

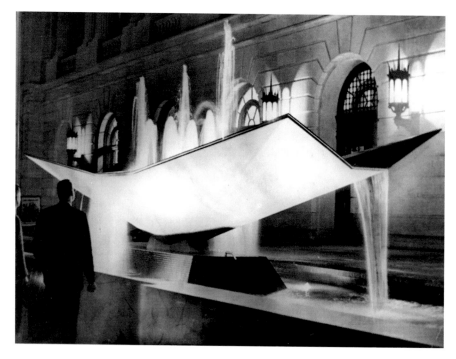

In 1962, a contemporary fountain memorializing the servicemen of World War II and Korea was installed in front of the post office on Front Street. The fountain was removed in 1970 following years of controversy involving the fountain's aesthetic and structural design.

INDEX

ABOUT THE AUTHOR

Laura Cunningham is a native Memphian and currently works at the Memphis Public Library. She is a graduate of the University of Memphis, where she completed her BA and MA degrees in history. She has worked with a number of the city's museums and historic sites, including the Mallory-Neely and Magevney House Museums. In 2006, she was awarded the Ruth and Harry Woodbury Graduate Fellowship in Southern History. She is also the author of *Haunted Memphis*.

Visit us at
www.historypress.net